Rodin's
Monument to Victor Hugo

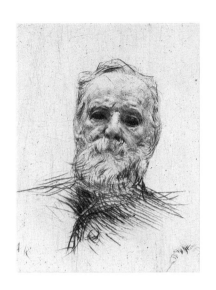

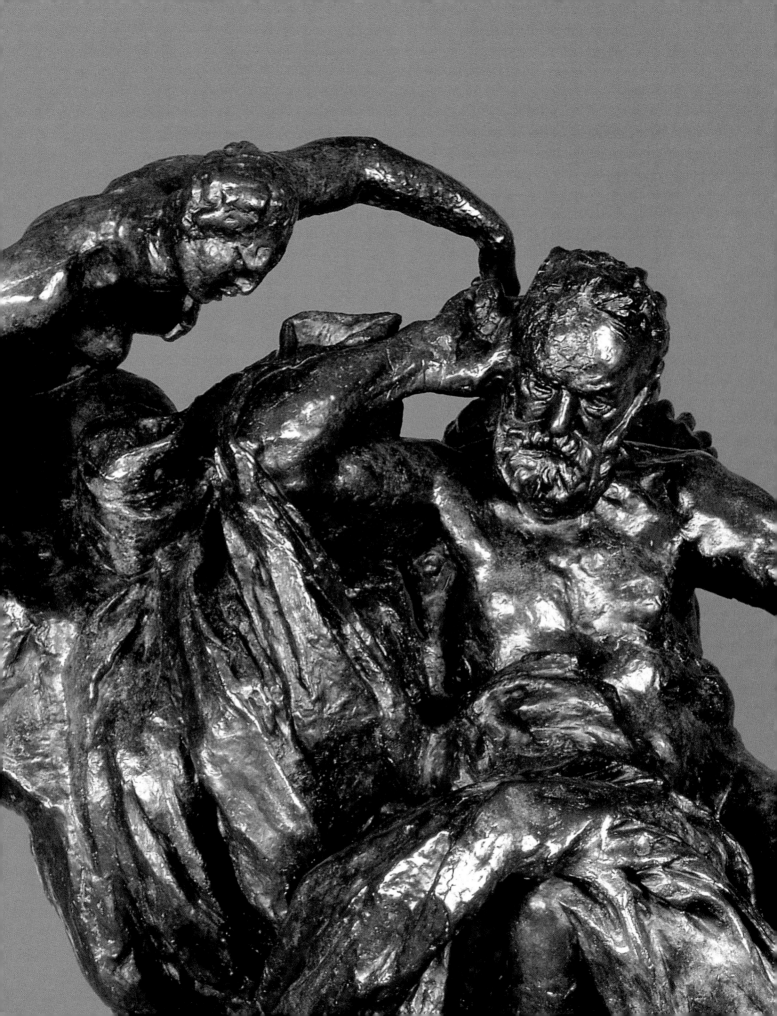

Rodin's
Monument to Victor Hugo

RUTH BUTLER

JEANINE PARISIER PLOTTEL

JANE MAYO ROOS

Exhibition organized by the
Iris and B. Gerald Cantor Foundation
Curated by Rachael Blackburn

MERRELL HOLBERTON
PUBLISHERS LONDON
in association with the
Iris & B. Gerald Cantor Foundation

This book accompanies the exhibition
Rodin's Monument to Victor Hugo

Exhibition itinerary:

LOS ANGELES COUNTY MUSEUM OF ART
December 17, 1998 – March 15, 1999

PORTLAND ART MUSEUM, OREGON
April 13 – June 11, 1999

THE METROPOLITAN MUSEUM OF ART, NEW YORK
October 7, 1999 – January 2, 2000

The exhibition was organized by the Iris and B. Gerald Cantor Foundation, Los Angeles

© 1998 Iris and B. Gerald Cantor Foundation
All Rights Reserved

Library of Congress Catalog Card Number: 98–68130

British Library Cataloguing in Publication Data
Butler, Ruth, 1931–
Rodin's monument to Victor Hugo
1. Hugo, Victor, 1802–1885 2. Rodin, Auguste, 1840–1917
3. Sculpture, French
I. Title II. Plottel, Jeanine P. III. Roos, Jane Mayo
731.8'2

ISBN: 1 85894 071 0 (exhibition paperback)
ISBN: 1 85894 070 2 (hardback)

Designed by Roger Davies
Edited by Mitch Tuchman
Produced by Merrell Holberton Publishers
Willcox House · 42 Southwark Street · London S E 1 1UN

Printed and bound in Italy

Front jacket: Auguste Rodin (France, 1840–1917), *The Monument to Victor Hugo* (detail)

CONTENTS

Foreword 9

Rodin's Victor Hugo Monument

RUTH BUTLER

15

Rodin's Victor Hugo

JEANINE PARISIER PLOTTEL

23

Steichen's Choice

JANE MAYO ROOS

45

Exhibition Checklist 117

Suggested Reading 119

Index 120

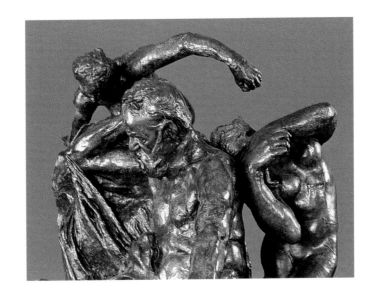

Lenders to the Exhibition

BROOKLYN MUSEUM OF ART

MRS. NOAH L. BUTKIN

COLLEGE OF THE HOLY CROSS, WORCESTER, MASSACHUSETTS

THE FINE ARTS MUSEUMS OF SAN FRANCISCO

IRIS AND B. GERALD CANTOR CENTER FOR VISUAL ARTS AT STANFORD UNIVERSITY

IRIS AND B. GERALD CANTOR COLLECTION

IRIS AND B. GERALD CANTOR FOUNDATION

LOS ANGELES COUNTY MUSEUM OF ART

MUSÉE RODIN, PARIS

RODIN MUSEUM, PHILADELPHIA

Foreword

The exhibition was organized to provide an introduction to Auguste Rodin's *Monument to Victor Hugo*, which is being presented to the United States for the first time. As the essays in this catalogue reveal, the story of Rodin's monument is a long and compelling tale of heated political disagreements born of French patriotism, the complex narrative of the Pantheon (which was the intended site for the monument), and the drama of Rodin's personal relationships with the author Victor Hugo, the sculptor Jules Dalou, and others. In the end, though Rodin exhibited a final plaster model at the Salon in 1897, the monument was not realized during his lifetime. Shortly after 1900 Rodin had refined the 1897 plaster and this served as the model for the first bronze cast, unveiled in Paris in 1964, and also for the bronze in this exhibition, which was commissioned in 1995 by B. Gerald Cantor through the Iris and B. Gerald Cantor Foundation.

Bernard Gerald Cantor (1916–1996) is widely acknowledged as having been the preeminent collector and proponent of Rodin in America during the second part of the twentieth century. His first Rodin, a bronze of *The Hand of God*, was purchased in 1946, after he was profoundly moved by seeing a marble version of it at the Metropolitan Museum of Art. For three decades Mr. Cantor was intent upon researching and acquiring work by Rodin, and in 1977 he was joined in this pursuit by his wife, Iris. All told, the Cantor Collection contained about 750 works by Rodin. The couple chose to give away more than 450 of them to over 70 museums around the world in addition to gifts of art by other artists and generous financial support. B. Gerald Cantor had previously commissioned, and then donated to various American museums, casts of each of Rodin's other major monuments: *The Monument to Balzac* (Los Angeles County Museum of Art), *The Gates of Hell* (Stanford University Museum of Art), and *The Burghers of Calais* (Metropolitan Museum of Art). This unique patronage and focus on Rodin, which Mr. Cantor called his "magnificent obsession," was second only to his devotion and love for Iris. She was his partner in both collecting and giving. It was for her that he commissioned the world's second bronze cast of Rodin's *Monument to Victor Hugo*, and it was through her that he intended to bring the monument to the United States; he also intended it to be a wonderful surprise for his wife. Sadly Mr. Cantor died before the lengthy casting process was complete. For the Cantor Foundation the joy of bringing one of Rodin's most important yet little-known sculptures to this country has helped to sustain the very grave loss of our founder and leader.

In addition to the work done by the Cantors, there are many others who

contributed to the creation of the monument and this exhibition. At the Musée Rodin, Jacques Vilain, Directeur du musée Rodin and Conservateur général du Patrimoine, offered his immediate support for the commission and worked closely with the Foundation throughout the duration of the casting. Antoinette Le Normand-Romain, Conservateur en chef au musée Rodin, kindly offered her gracious support, and Hélène Pinet, Jérôme Le Blay, and Stephanie Le Follic also offered invaluable and diligent assistance during the process, and their enthusiasm is greatly appreciated. The Foundation would also like to acknowledge the Maison de Victor Hugo, Paris, for its support and encouragement of the project.

At Coubertin foundry, where the magnificent bronze was created, the Foundation is grateful to Director Jean Dubos, who oversaw the casting, and to Evelyne Martin Poupeau, who attended to the myriad administrative details surrounding the casting process. On the technical side sincere gratitude is extended to Yann Audic, Manuel da Silva, Patrick Labarre, Roni Martins, Lahn N'Guyen, Francis Theron, and Bernard Touffait. The support of Pascale Grémont, curator of the Coubertin Foundation, is also greatly appreciated.

The Cantor Foundation was truly fortunate to have the participation of several significant Rodin scholars throughout the duration of the project. Ruth Butler, professor emerita at the University of Massachusetts in Boston, who wrote the introduction to this catalogue, offered her insightful guidance and worked closely with Mrs. Cantor, the Musée Rodin, and the foundry to determine the delicate nuances of the monument's patina. Other scholars who received Cantor Fellowships at Stanford University to study with the late Professor Albert Elsen also offered their support. The Foundation is grateful to Kirk Varnedoe, director of the Department of Painting and Sculpture at the Museum of Modern Art, New York, who offered in-depth advice and support during the genesis of the project, and for the helpful recommendations made by independent scholar Rosalyn Frankel Jamison and Kenneth Wayne, Joan Whitney Payson curator at the Portland Art Museum.

Under the guidance of Iris Cantor a partnership was realized between the Cantor Foundation and three important American museums to make the monument available to an audience across the country. At the Los Angeles County Museum of Art, appreciation and sincere thanks are due to Andrea Rich, president and CEO, and to Graham W.J. Beal, director and executive vice president, for their support and enthusiasm for the project. From the

Department of European Painting and Sculpture, Mary Levkoff, curator, deserves special accolades for her precision and elegance in absorbing many of the additional duties that came her way by virtue of LACMA's role as the first venue. Deep appreciation is also due to J. Patrice Marandel, curator of European Painting and Sculpture, and to Maureen Russell, associate conservator, Objects and Sculpture, and to Beverley Sabo, exhibition programs coordinator. At the Portland Art Museum, John E. Buchanan Jr., executive director, and Lucy Buchanan, director of development, both longtime friends of the Cantors, offered their support for the project from its earliest stages. The logistics of bringing the exhibition to Portland were managed capably by Donald Jenkins, chief curator. At the Metropolitan Museum of Art, New York, Director Philippe de Montebello was immediately enthusiastic about the project and has offered much support along the way. The Foundation would also like to acknowledge the gracious assistance of Mahrukh Tarapor, associate director, Exhibitions; Emily K. Rafferty, senior vice president for development and membership; Olga Raggio, Iris and B. Gerald Cantor chairman, European Sculpture and Decorative Arts; Clare Vincent, associate curator, European Sculpture and Decorative Arts; and Nina McN. Diefenbach, chief development officer. The Foundation is enormously grateful to these institutions and their staffs for sharing in its vision.

Toward the realization of this catalogue the primary essayists provided the indispensable research and documentation necessary to understand Rodin's *Hugo*. Professor Jane Mayo Roos, Hunter College and the Graduate Center of the City University of New York, did a splendid job exploring and clarifying the history of the monument, and Professor Jeanine P. Plottel, also of Hunter College and the Graduate Center, offered much insight into the heroic legacy of Victor Hugo and his relationship with Rodin. Mitch Tuchman skillfully edited the catalogue and Jim Drobka offered gracious help on its design. The Foundation is also grateful for the assistance of photographers Steve Oliver and Meidad Suchowolski and for the technical expertise of James R. Rodgers.

We extend our sincere thanks to those private collectors and institutions who have provided valuable information toward the compilation of this book and who have generously agreed to lend works to the exhibition, and wish to acknowledge Bernard Barryte, Mrs. Noah L. Butkin, Anne d'Harnoncourt, Elizabeth Easton, Carter Foster, Stephen Koja, Ellen Lawrence, Steven A. Nash, David Norman, Joseph J. Rishel, Peter Rose, Thomas K. Seligman, and Douglas Weinstein.

A note of appreciation is also due to several key staff members at the Israel Museum in Jerusalem: James S. Snyder, the Anne and Jerome Fisher director; Stephanie Rachum, the David Rockefeller curator of Modern Art; and Adina Kamien Kazhdan, assistant curator in the Department of Modern Art, who kindly assisted the Foundation during the early stages of this project.

At the Cantor Foundation several staff members also contributed their talents and expertise. In particular, we acknowledge the dedication and fortitude of Susan S. Sawyers (previously curator of exhibitions and later executive director), who worked closely with Mr. Cantor, the Musée Rodin, and the Coubertin foundry during the commission and casting processes. Danna Freedy served capably as assistant curator and registrar for the exhibition, and Jennifer Iverson, program officer, coordinated the initial financial and administrative tasks. Valuable administrative assistance was also provided by Joel M. Melchor and Brandy S. Sweeney.

The Iris and B. Gerald Cantor Foundation conveys sincere and deep gratitude to all of the aforementioned for making this project a reality.

RACHAEL BLACKBURN
Executive Director
Iris and B. Gerald Cantor Foundation

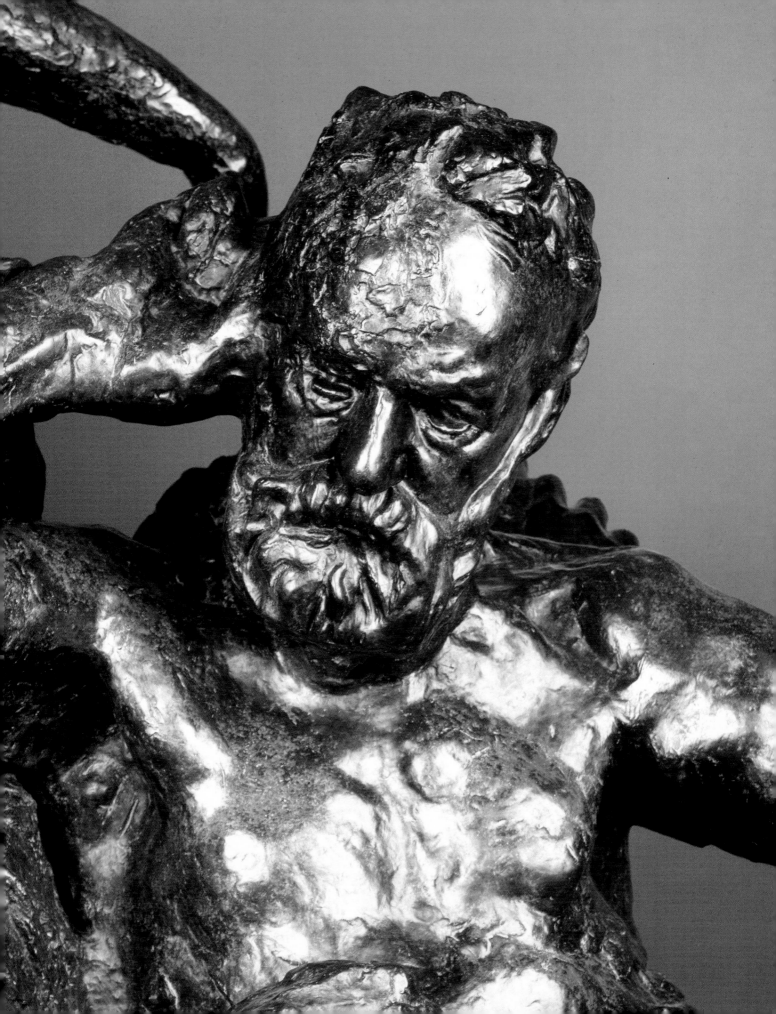

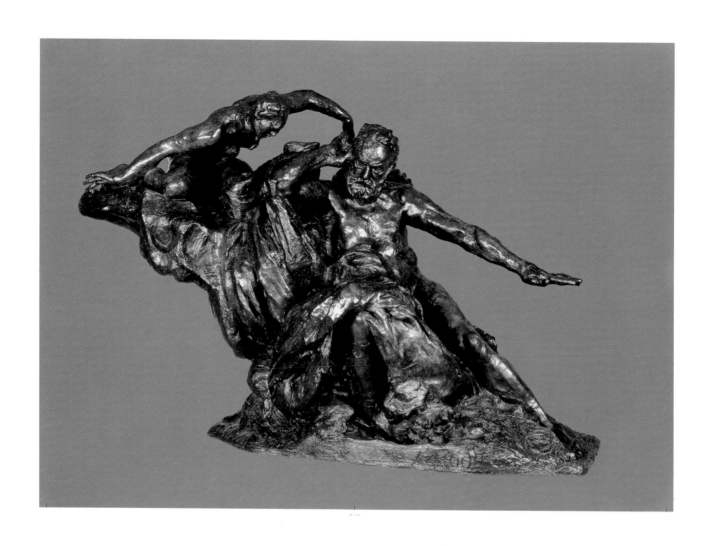

AUGUSTE RODIN
France, 1840–1917
The Monument to Victor Hugo

Rodin's Victor Hugo Monument

RUTH BUTLER

Victor Hugo's death provided the French government with the occasion to resecularize the Pantheon, the vast eighteenth-century church on the montagne Sainte-Geneviève, built in honor of Sainte Geneviève, patron saint of Paris. The death of Mirabeau in 1791 provoked the first secularization of the church, transforming it into a pantheon fit to receive the ashes of the great Revolutionary orator. During the Bourbon Restoration (1814–30), the enormous domed structure was returned to the Church, but Louis Philippe (1773–1850), whose monarchy ended Bourbon rule, chose to honor the Revolutionary Decree of 1791, and, less than a month after the "Three Glorious Days" that brought him to power in July 1830, the structure was once again transformed into a pantheon. During the Second Empire (1852–70), Napoleon III gave it back to the Catholic faith, making it necessary that yet another transformation take place in order that it might be an appropriate place to receive the body of the poet-patriot, who had made it clear that he was not to be buried in a church. On June 1, 1885, a million people followed Hugo's body from the Arc de Triomphe at the Étoile to the Pantheon on the montagne Sainte-Geneviève.

It took only a few years for the fine arts administrators of the Third Republic to draw up a newly conceived republican plan for the Pantheon. Included was a vast sculptural program for monuments dedicated to those men whom they considered the "greats" of the French Revolution. It would also include a monument to Hugo (1802–1885) as the individual who had carried the Revolution into the nineteenth century. The sculptor was to be Auguste Rodin (1840–1917). No commission ever meant more to Rodin than this one, and he worked on it for years. Nevertheless, when he finally showed the three-figure plaster group in the Salon of 1897, it was not finished. In fact, it was in such a rough state that gaping holes exposed its interior. Viewers could easily see that the entire piece was held together by iron rods. Given this fact, even Rodin must have been surprised by the overwhelmingly enthusiastic reception of the Salon audience and the extremely positive reviews of critics.

An important monument, initially well received, yet, strangely enough, little known. The work was not cast in bronze until the early 1960s. I remember going to see it in the carrefour Victor-Hugo-Henri-Martin, a complicated crossing, where three major streets intersect. The monument was not visible as I first surveyed the area. I asked a gentleman passing by if he knew where Rodin's *Victor Hugo* was located, unaware that it was in full view of where we stood, the dark monument obscured by the bank of evergreens planted behind it. My local host replied acidly, "I do not know, but when you find it, it will

give you no pleasure." I wondered if his enmity was aimed at Rodin or at Hugo and suspected it to be a burst of feeling directed at both artists by a singularly anti-Romantic individual of the sixteenth arrondissement.

The bumpy history of *Victor Hugo* began almost from its inception. When a committee came to look at Rodin's original plaster sketch in 1890, they were not pleased. The idea of the once-exiled poet seated on the rocks of Guernsey in the company of several muses did not seem appropriate for the space of the Pantheon, nor did the committee in charge of the Pantheon program believe that it worked well as a pendant for the monument to Mirabeau with which Rodin's work was being paired. And so it was rejected, but Gustave Larroumet (1852–1903), the sympathetic bureaucrat in charge of the commission, encouraged Rodin to keep working on it. He would find an alternative site in one of the gardens of Paris. Rodin, furthermore, was granted a second chance to create something the committee might find acceptable for the Pantheon, something grander in both idea and scale. He then set about working on *The Apotheosis of Victor Hugo*. But the politics of the whole enterprise were not right, and somewhere along the way the government lost interest in both Rodin monuments.

Paris welcomed the turn of the century with a great Universal Exposition, at which Rodin mounted his huge retrospective in the place d'Alma. People from all over the world came to see his work, and he found he had arrived at a position of singular fame. So, as Rodin looked ahead to the centenary of Hugo's birth, which would take place in 1902, he felt surely now his *Hugo* might play a role. He knew the major official recognition of the event was to be the inauguration of a monument to Hugo by Ernest Barrias (1841–1905), which had been commissioned in 1896, but surely his own monument could find a place somewhere in Paris. Rodin had the seated figure of Hugo carved in marble for the Salon of 1901, but the Paris recognition of Hugo's birthday was placed in the hands of only three sculptors: Barrias with his gigantic monument in the place Victor-Hugo; Georges Bareau (1866–?) with a monument for the place des Vosges in front of the house that had been the Hugo family residence from 1832 to 1848; and Antonin Mercié (1845–1916), who placed a bust of Hugo at the entrance to the Senate. Rodin's work played no part in the centenary celebration.

At this point Rodin must have been tempted to give up on his *Hugo*, as he had a few years earlier on his *Balzac*, which he had taken home to his garden following its rejection by the Société des gens de lettres and the vicious critical reception at the Salon of 1898. But the marble *Victor Hugo* was saved

AUGUSTE RODIN
France, 1840–1917
The Monument to Victor Hugo

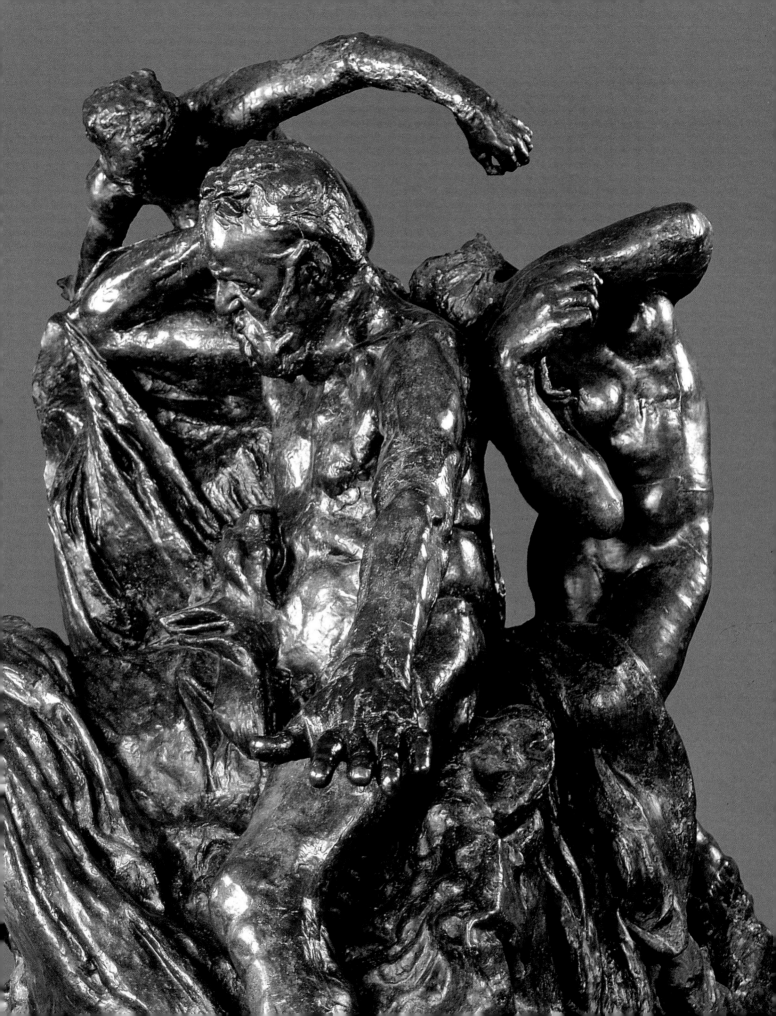

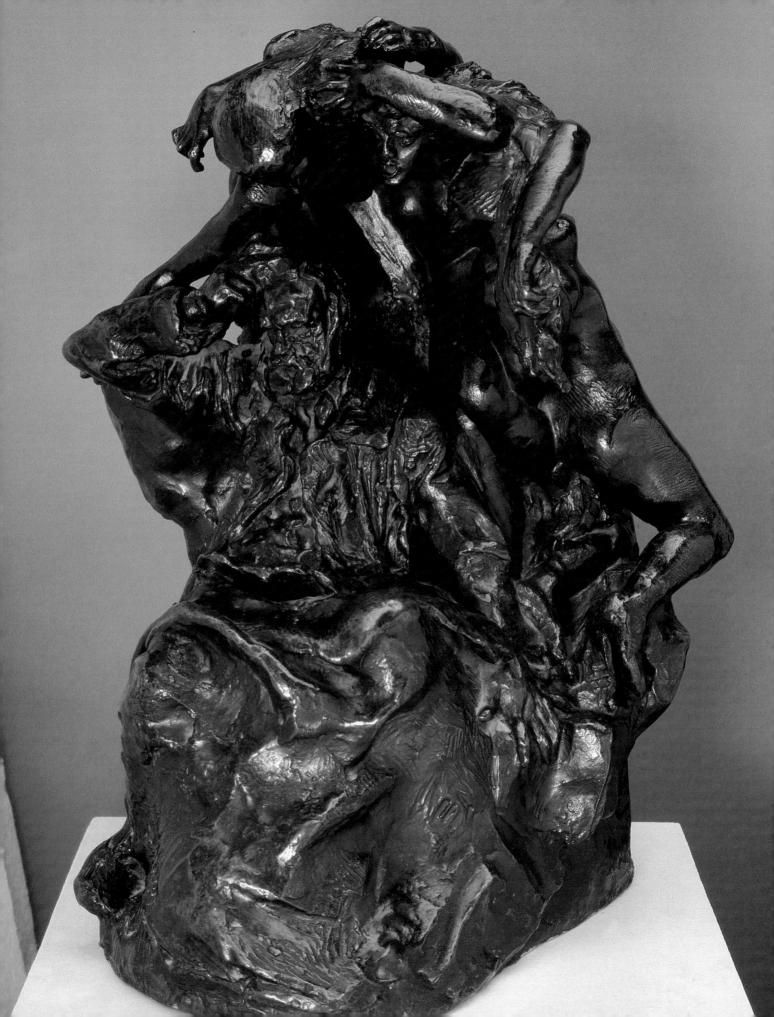

AUGUSTE RODIN
France, 1840–1917
Maquette for The Monument to Victor Hugo

by yet another highly cultivated, enthusiastic administrator who came into Rodin's life in the twentieth century. This was Henri-Charles-Étienne Dujardin-Beaumetz (1852–1913), who had been appointed undersecretary for fine arts in January 1905. Dujardin-Beaumetz officiated at the unveiling of Rodin's enlarged *Thinker* in front of the Pantheon a year later, and from this time on, until the end of his term in 1912, he was ever attentive to what he could do for Rodin's work. He took the initiative in finding a site for the marble *Hugo*. The location he chose just happened to be in full view of his own office in the Palais-Royal. Rodin had decided not to carve the figures of the muses but to place the seated Hugo by himself in the garden of the Palais-Royal, where it was installed in the fall of 1909. The monument remained in this setting until 1933, when the ill effects of Paris weather made it necessary to send it to the Musée Rodin.

Early during the occupation of Paris (1940-44), the Germans disassembled Barrias's *Monument to Victor Hugo*. They melted down his over-life-size bronze figures and four bas-reliefs and obliterated the granite base. A permanent site for the Bareau monument, which had been in plaster in 1902, had never been found (the marble version was finally installed in the Jardin du Ranelagh in 1985), so as the year 1952, which was to be the 150th anniversary of Hugo's birth, approached, a question arose in official circles: Is it possible that Paris could remain without a major monument to Victor Hugo? Clearly not. Raymond Escholier (1882–?), art historian, Hugo scholar, and, as a young man, an acquaintance and admirer of Rodin, proposed a national subscription "to raise a monument worthy of Victor Hugo." He felt it was obvious that there was but one sculptor's work appropriate for this situation: Rodin's. In an article in *Nouvelles Littéraires* (3 April 1952) Escholier described and illustrated the three-figure plaster in the Musée Rodin, a work that had been so out of view for the past fifty years that it was neither mentioned nor illustrated in the official catalogue of the museum, a catalogue generally considered as nearly complete.[1] Escholier raised the question of where the work should be sited. He ruled out the place Victor-Hugo, which he now saw as barren and deprived of all character by the insult it had suffered during the War. He proposed the eastern point of Île de la Cité, a place from which one could easily take in Notre Dame, the Pantheon, and the place de Grève (now the place de l'Hôtel de Ville).

Other voices spoke up for the original site in the place Victor-Hugo, and still others put in a word for the place des Vosges. As the idea took on momentum, the plan of having Rodin's original *Monument to Victor Hugo* cast in

bronze picked up support. At least one contemporary artist, however, put himself forward as a candidate for an alternative monument: Picasso (1881–1971). The city of Paris had just turned down his proposal for a monument to Apollinaire. It was probably in reaction to this disappointment that he asserted in a 1952 interview his willingness to be considered "number one on the list of candidates" if a new monument to Victor Hugo were under consideration. When asked what he thought of Rodin's monument, he was critical: not "clear," it did "not give enough information." We cannot help but wonder what kind of information would have been imparted by a Picasso monument to Victor Hugo.[2]

The members of the National Education Ministry and those of the Municipal Council reached an agreement to share the expense of casting and placing Rodin's original monument, which they understood to be the replacement for the destroyed Barrias. But the agreement was not quite firm; the state reneged on its part of the payment, and the monument was fourteen years in coming. Rodin's *Monument to Victor Hugo* was finally unveiled June 18, 1964, not on the original site in the place Victor-Hugo, but in the angle where the avenue Victor-Hugo meets the avenue Henri-Martin. "Paris Has Reclaimed Her Poet" was the headline of the day, and Rodin's monument, rejected seventy-two years earlier, finally had a permanent home.

The events and speeches of that June day, however, were focused on Hugo, not Rodin. The world would wait another thirty-two years for a second cast of this highly original and very important monument to be made. It was the last wish of Bernie Cantor, Rodin's most dedicated collector in the latter part of the twentieth century, that another cast be made. As was so often the case in Mr. Cantor's passionate concern for Rodin's works, he recognized the importance of the Hugo monument and was loath to leave the world without making it accessible to all – and especially to Americans. With great concern and singular attention, Iris Cantor then stepped in to carry out the execution of her husband's wish. We are now able to enjoy the fruit of their shared love of Rodin in this exemplary exhibition created around the new cast of Rodin's *Monument to Victor Hugo*.

1. George Grappe, *Catalogue du musée Rodin* (Paris: Musée Rodin, 1927, 1929, 1931, 1938, 1944).
2. "Le Rodin ne raconte ni assez de choses, ni assez clairement." "Picasso offre de faire un monument pour Paris," *Tous les arts*, 20 March 1952 (interview with Georges Meyzargue).

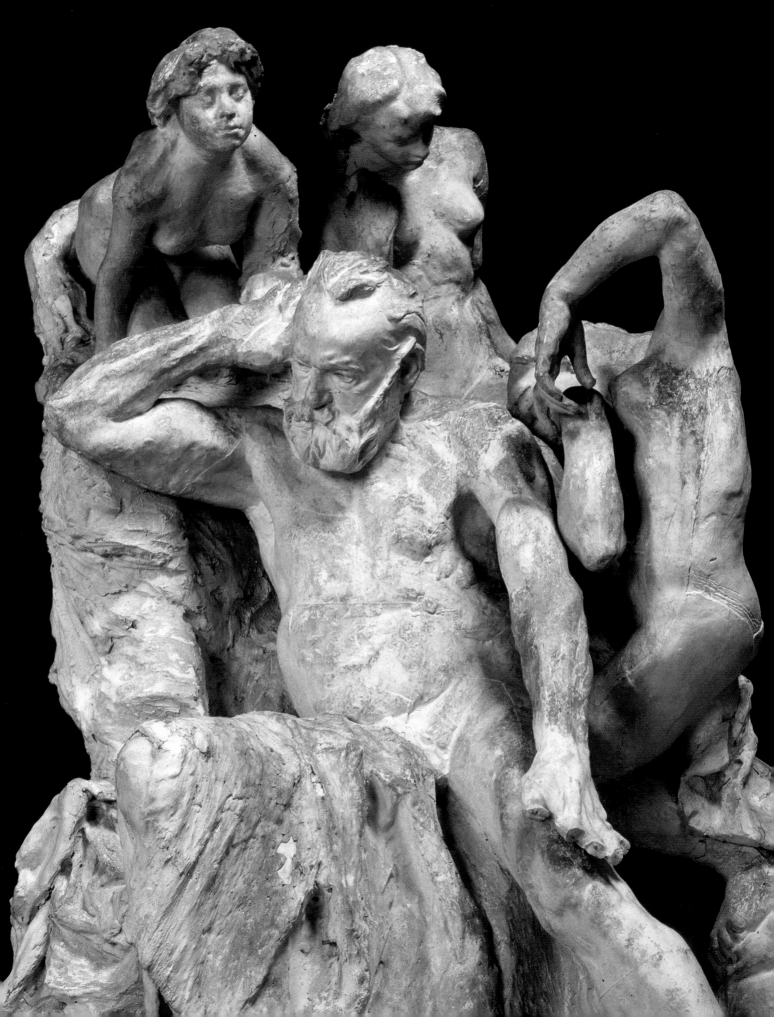

Figure 1
LÉON BONNAT
France, 1833–1922

Portrait of Victor Hugo

1879
Oil on canvas
Versailles, Musée National du Château
Photo: © Bulloz

Rodin's Victor Hugo

JEANINE PARISIER

PLOTTEL

The author believes that every true poet ... must contain the total sum of all the ideas of his time [*L'auteur pense que tout poète véritable ... doit contenir la somme des idées de son temps*][1]

VICTOR HUGO

A true artist always places both his time and his soul in his work [*Un véritable artiste met toujours son temps dans son oeuvre et aussi son âme*][2]

AUGUSTE RODIN

When Auguste Rodin began working on a monument to the memory of Victor Hugo to be placed in the Pantheon, barely a year had passed since the great man's remains had been placed in the sanctuary.[3] Neither the majestic ceremony nor the presence of the century's sublime master had yet faded into history. The making of a shrine would be an awesome accomplishment because it would necessarily embody for posterity the legacy of the nineteenth century's leading genius.

The sovereign of the French Republic of Literature died at his home in Paris, 130 avenue d'Eylau, on Friday, May 22, 1885, at 1:27 p.m. Before a suitable state burial could be orchestrated, several intricate transactions had to take place, a summary of which provides a glimpse of the context of Rodin's commission and its significance.

It was decided that it would be appropriate to change the name of the street on which he died before orchestrating a suitable state burial. Already in 1881, when he entered his eightieth year, a section of the avenue d'Eylau, commemorating one of Napoleon's battles, had been renamed avenue Victor-Hugo. Now this name was adopted for the street's entire length.

There was also the question of the funeral itself. The Chamber of Deputies immediately drafted and overwhelmingly passed (by a vote of 415 to 3) a bill honoring the author with a state funeral, but how would the instructions in Hugo's last will and testament, which had been published and distributed all over Paris, be carried out? The will explicitly stated, "I give 50,000 francs to the poor. I want to be carried to the cemetery in a pauper's hearse. I reject the orations of all churches; I ask every soul to pray for me. I believe in God."[4]

The goal was to conciliate Hugo's modest instructions with arrangements for the most majestic funeral in history, one that would be more impressive than any ceremony previously choreographed for anyone, including the kings of France themselves. Now that he was to be buried in the Pantheon, this church, built by Louis XV as an offering to Sainte Geneviève, patron saint of Paris, a church that had by turns been consecrated and secularized, had to be restored to the civil function decreed by the Constituent Assembly during the French Revolution in 1791: the Pantheon would again serve as the final resting place for France's greatest men, or in the words of the inscription on the pediment: AUX GRANDS HOMMES LA PATRIE RECONNAISSANTE [To great men their grateful country]. Finally, not only was the Sainte-Geneviève church taken away from the clergy, but its large cross was removed.

Early Sunday morning, May 31, 1885, the greatest state funeral France has ever known got under way. The Hugo family and the mayors of the twenty arrondissements of Paris filed behind the coffin, which was to lie in state for twenty-four hours under the Arc de Triomphe. More than ten thousand people stayed up all night to witness the transfer of the casket to a hearse at six in the morning. All day long a seemingly endless stream of Parisians paying their last respects huddled closely, falling into queues along the Champs-Élysées, the only approach to the Arc that remained open. The monument had been specially decorated for this occasion by Charles Garnier (1825–1898), the architect of the Paris Opéra, completed in 1875. Veils of black crepe draped the Arc, which even in daytime was lit with gas. Beneath the pauper's coffin was an immense urn raised on a two-tiered pedestal draped with dark velvet. Everywhere on the place de l'Étoile there were black banners with white fringes inscribed with the titles of Hugo's works, and his initials, a giant V.H., crowned the Arc, creating a sort of canopy. An honor guard of schoolchildren in uniform took turns watching the body. At dusk the death watch was intensified. Huge masses now streamed from all the avenues – Iéna, Hoche, Friedland, Alma, Marceau, Kléber, Hugo, du Bois (now avenue Foch), and Grande Armée – converging on the Arc de Triomphe. The long death watch marked the "moment when," in the words of the novelist Maurice Barrès (1862–1923), "the corpse presented to the nation became a god."[5]

A night of revelry, frenzy, and orgy followed. The cult of the dead Hugo turned into a celebration of life as Thanatos gave way to Eros. In his diary, Edmond de Goncourt wrote:

It seems that the night preceding Hugo's burial, the night vigil of a downcast people, was celebrated with an immense copulation, an orgy of brothel ladies on holiday with ordinary men on the lawns of the Champs-Élysées – republican marriages honored by the police.[6]

Barrès confirmed this saturnalian spirit:

Like all cults of the dead, the funeral exalted one's sense of life. For this corpse, the crowd conceived a grand concept. We felt smaller, and a strange fire flowed through one's veins. It was as beautiful as the docks of great ports, as violent as the tide, the strong stench of which strengthens us by filling us with desire. The benches of the Champs-Élysées, the shadows of its woods, were sites of an immense debauchery that lasted until dawn.

The Paris night went outdoors. Except for its beacon, this uneasy world would have been in chaos. – A carnival? No, a coffin surrounded by humanity! ... Night of May 31, 1885, a dissolute and pathetic night of vertigo, in which Paris was obscured with the vapors of her love for a relic. The great city may have been trying to compensate its loss. Did these men, these women have a hint of the burning chance whence genius stems? How many women gave themselves to lovers, to strangers, with the true fury of one seeking to become the mother of an immortal child? The children of Paris who were born in February 1886, nine months after this delirium, should be closely watched.[7]

Surely to the mind of the nineteenth century, imbued with the concept of genius, Eros was a fitting accompaniment for the wake of the greatest genius of all. Was it not widely believed that love was an important ingredient in Hugo's greatness?

The next morning at eleven o'clock a twenty-one-gun salute was sounded, and the humble pauper's hearse, followed by gardens of flowers, left the Arc de Triomphe and traveled down the Champs-Élysées to the strains of Frédéric Chopin's funeral march. For the next six hours the largest funeral procession ever to flow through Paris in this way – from one to three million persons – escorted Victor Hugo to the Pantheon. All the other streets of Paris were deserted; all its stores closed. Barrès best captured the intensity of emotion that seized the nation – and perhaps Rodin himself:

From l'Étoile to the Pantheon, Victor Hugo comes forward, and everybody accompanies him. He was the pride of France, and now he enters its heart. The genius of our race now withdraws unto itself. After flourishing throughout the world, it now returns to its center. It will join the body of our tradition. From the Arc where the poet was the host of Caesar, we accompany him to the unsinkable Ark, transforming his excellence into the ideas that will henceforth stimulate French energy.[8]

I have noted that this magnificent funeral overshadowed the funerals of all the kings of France. It also eclipsed the return of Napoleon's remains from St. Helena, the ceremony that had certainly set the pattern followed by the planners of Hugo's rites. In December 1840, a month after Rodin's birth, a procession, smaller than the one for Hugo, followed the fallen emperor's coffin from the Arc de Triomphe to the crypt beneath the dome of the Invalides. Napoleon's name was still very much linked with the old "poet-prophet's"[9] in the years when Rodin began his plans for the monument to Victor Hugo, and his exploits still exalted French hearts.

Rodin had met Hugo two years earlier, in 1883, when he visited the poet in order to make a bust. "The first time I saw Victor Hugo," he is purported to have recounted to his friend Henri-Charles-Etienne Dujardin-Beaumetz more than twenty-five years later,

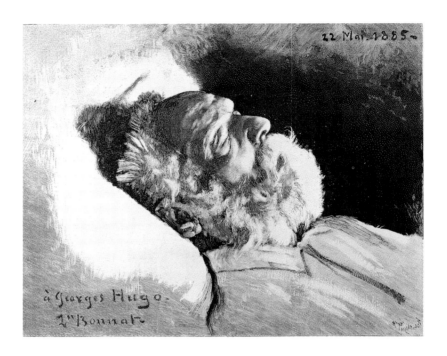

He made a profound impression upon me. His eyes were magnificent. He seemed terrifying to me. He was probably affected by angry or hostile thoughts because his natural expression seemed that of a good man. I thought I had seen a French Jupiter. When I got to know him better, he seemed to be more like Hercules than Jupiter.[10]

The various descriptions of Rodin's encounters with the venerable "Olympio" (as Hugo called himself) are considerably more lighthearted. Anna de Noailles (1876–1933), the most famous woman poet of her day, described a session with Rodin, who was sculpting a bust of her head (a bust that she disliked and refused to purchase):

He told me how he made Hugo's bust: "Mme Drouet [(1806–1883), a former actress and model and Hugo's mistress], who knew me, spoke of me to her 'husband.' He [Hugo] flew into a rage at the idea of posing and said: 'He can come and see me all he wants. I won't pose. I don't even want to see a pencil.' So I went to lunch, dinner. He would say: 'Bonjour, Monsieur Rodin.' Nothing else. The contempt he had for me was extraordinary. I drew sketches as best as I could. And then after his meals, when he fell asleep, I came forward softly and I took my measurements."[11]

A stroke Hugo suffered in 1878 led him to curtail his writing. (Interestingly, one of his last public appearances had been a visit to the atelier

of Frédéric-Auguste Bartholdi [1834–1901] in order to see his statue of Liberty on November 29, 1884.)[12] He himself does not seem to have left any written account of his encounter with Rodin, and we can only speculate about how he viewed the sculptor. If we turn to Rodin's acquaintance Edmond de Goncourt and to his literary portrait of Rodin in 1886, we can appreciate that the sculptor's extravagant appearance may not have suited the bourgeois Hugo entourage:

In the afternoon, [the painter and engraver Felix] Bracquemond [1833–1914] takes me for a visit to the sculptor Rodin. He is a man whose features are those of the people, a fleshy nose, blinking light eyes with sickly red eyelids, a long pale yellow beard, with short hair brushed back, a round head, a soft bullheaded stubbornness. Physically, he is how I imagine Jesus Christ's disciples.[13]

Dujardin-Beaumetz tell us that Rodin worked on a veranda filled with flowers and green plants at Hugo's residence.[14] Sometimes he would see Hugo go through the salon, with a "cold and hard expression." Or he might simply sit at the far end of the room "absorbed in thought." Hugo held that since Pierre-Jean David d'Angers (1788–1856), whom he greatly admired, had already made a bust of him, there was no point in anyone else sculpting him. He imagined Rodin's rendering of him was awful, but he did not actually bother looking at it. "His entourage criticized it so much," confided Rodin, "that I was somewhat discomfited.[15] Rodin told Goncourt that he had made a lot of quick sketches, about sixty, "from the right, the left, bird's-eye views, almost all of them foreshortened in attitudes of meditation or reading – sketches upon which he was forced to depend in order to build his bust."[16] He rejected the family's conventional view of the great writer. Instead he modeled a likeness copied from nature rather than from the stereotypical mask established by the literature of his time.

When he became acquainted with Hugo, the latter was a much diminished man. In fact, Hugo's stroke may not have been his first. Scant attention has been paid to a June 30, 1875, notation in his diary: "I felt the bizarre phenomenon of an abrupt eclipse of memory. It lasted about two hours."[17] The event occurred when he still had ten years to live, and perhaps Rodin was affected by the ebbing of his model's corporeal, personal, intellectual, and psychological gifts. It is striking that in the Dujardin-Beaumetz account Rodin stresses that he sought to convey his very first impression: Jupiter rather than Hercules. I read here Jupiter, the primal god, rather than

Hercules, a mere man. Are we to suppose that actual contact with Hugo and his entourage fell short of Rodin's expectations? Is this an instance of a gap between reality and its representation? Where his soul sought a divinity, his eye saw a man, albeit a strong man, but a man, nevertheless. Would his monument reconcile what he saw, what he knew, and what he was meant to see? How would he shape the ensuing concepts and visions into an appropriate sculptural form? A brief review of how Hugo's legend was shaped by his actual achievements may yield some answers to these questions.

Every French schoolchild knows that when Hugo was born, the nineteenth century was but two years old ("*ce siècle avait deux ans*"), and his presence would fill it almost to the end. He was born on February 26, 1802, the Year X of the Republic, at Besançon, an old Spanish town ("*vieille ville espagnole*"), the son of Joseph-Léopold-Sigisbert Hugo (1773–1828) and Sophie-Françoise Trébuchet (1772–1821). He had two older brothers, Abel, born in 1798, and Eugène, in 1800. By the time he entered the world, his parents' marriage had deteriorated. Their acrimonious relationship, repeated separations, and spurious reconciliations clouded Victor's early years, stamped also by travels to Marseilles, Corsica, Elba, Italy, Spain, and other places, where his father, an officer who eventually rose to the rank of general, was stationed. The idyllic memories of the poem "Aux Feuillantines"[18] give a sunny version of a carefree childhood. It is part of the Hugo myth that, very early on, this optimistic account was incorporated by France's educational establishment as a Third Republic reference worthy of emulation by all its pupils. Actually, in a dangerous period of war and civil unrest the young boy experienced chaotic domestic conditions, moving about from place to place, between one parent and the other, both of whom he loved deeply. In this vein let us note that Jean-Pierre Richard, one of the best readers of French poetry in general and Hugo in particular, wrote that the origin of the world according to Hugo, and the source of Hugo's own verbal creation, was to be found in the chaos motif, a motif that affected all regions of his experience.[19]

In spite of the turmoil the boy was given an excellent education, one that was solidly grounded in the classics. To the end of his life he remained an excellent Latinist, able to write Latin verses and to read Horace, Juvenal, Virgil, Lucretius, and others. From 1816 to 1818 he was a boarder in the Pension Cordier, and he attended the Lycée Louis-le-Grand, then as now one of the most prestigious high schools in Paris. He studied philosophy and mathematics in order to prepare himself for the École Polytechnique.

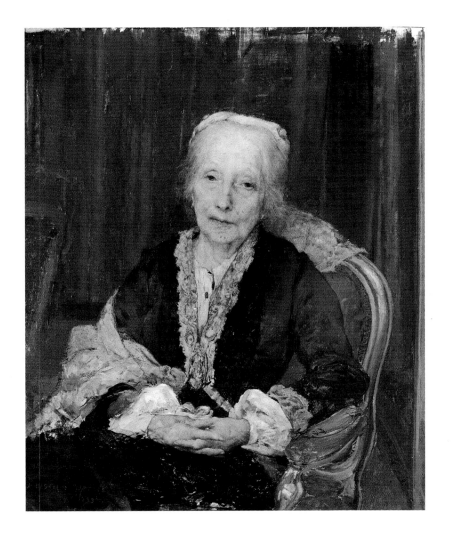

Figure 5
JULES BASTIEN-LEPAGE
France, 1848–1884

Portrait of Juliette Drouet

1883
Oil on canvas
Paris, Maison de Victor Hugo
Photo: © Photo Bulloz

By 1816 the fourteen-year-old Hugo was assiduously writing verses. On July 10 of that year he is supposed to have written the following sentence in a school notebook: "I want to be Chateaubriand or nothing [*Je veux être Chateaubriand ou rien*]."[20] His published juvenilia, termed by the author himself "the Foolishness in which I engaged before my birth [*les Bêtises que je faisais avant ma naissance*],"[21] are testimony that he was a child prodigy of verse. He mastered all the technical subtleties of French versification while still in his teens. Charles Baudelaire (1821–1867), himself an incomparable connoisseur in these matters, imagined that in a previous life Hugo had fed on the dictionary of the language he would be called upon to speak. "The French lexicon came forth from his mouth and became a world, a colored, moving, and melodious universe."[22]

In 1819 the seventeen-year-old first came to the attention of his fellow

writers by founding and publishing a literary journal, *Le Conservateur littéraire*. His first book, *Odes et poésies diverses*, was published in 1822, a few months after his twentieth birthday. Poems were added and others dropped as the book went into its second, third, and fourth editions, and in 1828 a fifth edition was printed with a revised title, *Odes et ballades*. The next year a new volume, *Les Orientales*, provided a view of oriental lore captured by Byron's verses and Delacroix's paintings.

The quantity of his output while he was still in his twenties was extraordinary. Apart from poetry he wrote and successfully published several novels: in 1823 *Hans d'Islande*, a melodramatic Gothic novel in the style of Walter Scott; in 1825 *Burg-Jargal*, a revised version of an 1818 novella about a 1792 slave revolt in Santo Domingo; in 1829 *Le Dernier Jour d'un condamné* (The last day of a condemned man), a plea against capital punishment. *Notre Dame de Paris* – Hugo hated the English title, *The Hunchback of Notre Dame* – was finished in 1831.

In these years Hugo also wrote extensively for the theater, and success came often, but not consistently. *Cromwell* was printed in 1827; its celebrated preface set forth the aesthetics of French Romantic drama and buried practices of French classical tragedy observed by Corneille, Racine, and Voltaire. *Amy Robsart*, a flop, had only one performance at the Odéon in 1828. The triumphal premiere of *Hernani* (1830) made Victor Hugo a celebrity. *Marion Delorme* (1831) was scheduled to be performed at the Théâtre français but was forbidden by the royal censors.

During this fruitful period Hugo entered into traditional domestic arrangements. At the age of twenty and following the death of his mother, who had not given her consent for his marriage, he married Adèle Foucher (1803–1868), a young woman he had loved since childhood. The couple produced five children in rapid succession: Léopold (b. 1823), who died in infancy; Léopoldine (1824); Charles (1826); François-Victor (1828); and Adèle (1830).

I doubt Rodin actually had Mme Hugo in mind when he modeled the muse of Hugo's youth for his initial *maquette* of the funerary monument (figure 36). In that version he mounted three muses behind the poet: "the three muses of Youth, Maturity, and Old Age, offering whispered inspiration?"[23] Embodying Hugo's first love in this way is in tune with the Romantic age. Muses, goddesses of the arts, are a commonplace motif of the period. For example, in the 1830s Hugo's colleague, Alfred de Musset (1810–1857) framed his *Nuits* (Nights; 1835, 1836, 1837), a poetic account of

his love affair with George Sand, as dialogues between the poet and his muse.

When Adèle entangled herself with her husband's friend Charles Sainte-Beuve (1804–1869), an important critic but a second-rate poet and novelist, the naiveté of youth gave way to the compromises of maturity. With the years, Hugo's own amorous pursuits reached colossal proportions, but, in fact, it was his wife who had initiated the breach of the matrimonial covenant. He soon found solace elsewhere, with Juliette Drouet. What may be termed Hugo's youthful period came to a close more or less at this time. He had reached his thirtieth year, and his books had made him famous. The youthful muse, the muse on the left in Rodin's model of March 22, 1890, which can also be identified as *Les Orientales*, symbolizes Hugo's technical brilliance and proficiency. It expresses the verbal genius of one whose versatility and craft rejuvenated French verse and revolutionized its theater. The poem "Réponse à un acte d'accusation" (Answering charges), in *Les Contemplations*, explains how he changed the conventions of Neoclassical good taste and allowed low and higher words to mingle freely. He freed French poetic language from the shackles that had held it bound for more than 150 years.

I should like to propose Juliette Drouet as the model of the Muse of Maturity. Hugo met her in February 1833 at the Théâtre de la Porte-Saint-Martin, where she was performing in the minor role of the Princess Negroni in his play *Lucrèce Borgia*. She had been the mistress of the sculptor Jean-Jacques ("James") Pradier (1792–1852), and he was the father of her daughter, Marie-Sophie Claire Pradier (1826–1846). In his youth Rodin had admired Pradier, a professor at the École des beaux-arts, who had received the commission for the sculpture of Twelve Victories on Napoleon's coffin. Juliette was one of his models, and his sculptures of her naked body were to be found all over Europe. Is it a coincidence that one of his statuettes was called *Les Trois Grâces* (The Three Graces)?[24] Pradier's muse had become Hugo's, and their liaison lasted for fifty years, until her death in 1883.

An "arrangement" was probably reached with Mme Hugo, and a period of intense creativity followed. Juliette was an intelligent, delicate, and magnetic woman, who has not been given the credit she deserves. Her letters to Hugo, for example, are remarkable, lively, witty, and passionate, and they show that she remained level-headed in the face of her lover's most extravagant forays. I am thinking, for example, of her skepticism with his turning tables and his experiments in the world of spirits and the occult. Her sense was that such things were threatening to one's sanity, and she expressed her opinion forcefully and without ambiguity.[25]

Figure 6

CHARLES GALLOT

Victor Hugo

April 12, 1885
Photograph
Paris, Maison de Victor Hugo
Photo: © Photo Bulloz

Figure 7

ACHILLE DÉVÉRIA

Victor Hugo

1829
Engraving
Paris, Maison de Victor Hugo
Photo: © Photo Bulloz

During this time of his life, a time that coincided with the July, or bourgeois, monarchy (1830–48) of Louis-Philippe, the "Citizen King," Hugo's output of plays – *Le Roi s'amuse* (The king amuses himself [1832], the source of Verdi's *Rigoletto*); *Lucrèce Borgia* and *Marie Tudor* (1833); *Angelo, tyran de Padoue* (Angelo, tyrant of Padua, 1835); and *Ruy Blas* (1838) – and poetry – *Les Feuilles d'automne* (Autumn leaves, 1831) – was followed by three more volumes of verse: *Les Chants du crépuscule* (Songs of twilight, 1835); *Les Voix intérieures* (Inner voices, 1837); *Les Rayons et les ombres* (Light and shadow, 1840), titles that appear suggestively in some of the archival material about the various versions of Rodin's monument cited by Jane Roos in the following essay.

In *Les Feuilles d'automne* and *Les Rayons et les ombres* Hugo wrote several rather mediocre poems for the sculptor David d'Angers. They may have been relevant to Rodin, however, and one wonders whether he read them. Here are some verses from the earlier volume Hugo sent to the sculptor on June 21, 1830:

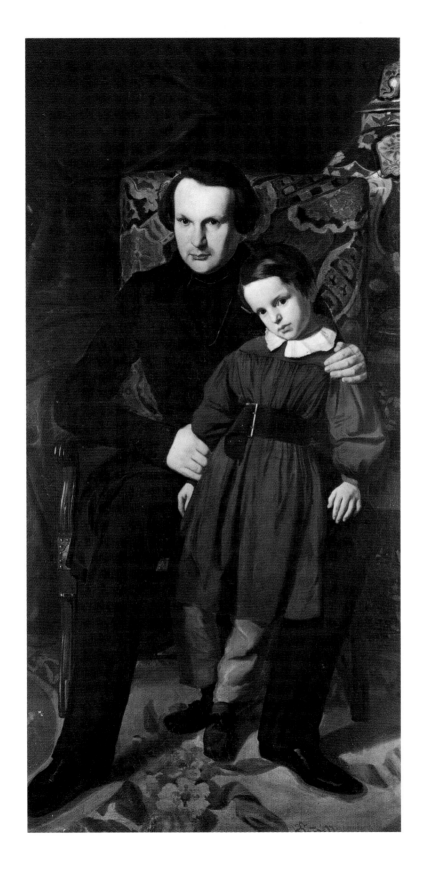

Figure 8

AUGUSTE DE CHÂTILLON
France, 1814–1859

*Portrait of Victor Hugo and
His Son, Victor*

1836
Oil on canvas
Paris, Maison de Victor Hugo
Photo: © Photo Bulloz

Que n'ai-je un de ces fronts sublimes,

David! Mon corps, fait pour souffrir,
Du moins sous tes mains magnanimes
Renaîtrait pour ne plus mourir!
Du haut du temple ou du théâtre,
Colosse de bronze ou d'albâtre,
Salué d'un peuple idolâtre,
Je surgirais sur la cité,
Comme un géant en sentinelle,
Couvrant la ville de mon aile,
Dans quelque attitude éternelle
De génie et de majesté![26]

How I wished I had a sublime
 forehead
David! My body meant to suffer
Under your magnanimous hands
Would be reborn and never die!
Above the temple or the theater
Colossus of bronze or alabaster
Greeted by a heathen populace
I should leap upon the city
Like a giant sentinel
Covering the town with my wing
In an eternal pose
Of majesty and genius!

Hugo and David d'Angers met in 1827. The following year the sculptor made a medallion of the poet. In 1837 and later in 1842 he fashioned his two celebrated busts. "Au statuaire David" in *Les Rayons et les ombres* is a long and complicated homage, and many of the names celebrated in the poem allude to David d'Angers's works. These new verses, far superior to those of the previous poem, have application as verbal representations of Rodin's own "prophetic greatness":[27]

N'est-ce pas? c'est ainsi
 qu'en ton cerveau, sans bruit,
L'édifice s'ébauche et l'oeuvre
 se construit?
C'est-là ce qui se passe en ta
 grande âme émue
Quand tout un panthéon
 ténébreux s'y remue?
C'est ainsi, n'est-ce pas, ô maître!
 que s'unit
L'homme à l'architecture
 et l'idée au granit?
Oh! qu'en ces instants-là ta
 fonction est haute!
Au seuil de ton fronton tu reçois
 comme un hôte

Isn't it how in your brain, silently

The structure is launched and the
 work is built?
That is what happens when a
 darkened Pantheon
Stirs and troubles your
 great soul.
Is this not how, oh master!

Man is linked to architecture,
 and idea to granite?
Oh! In such moments your purpose
 is a mighty one!
At the threshold of your pediment
 you greet as a host

Ces hommes plus qu'humains.	These men who are more than
Sur un bloc de Paros	human. On a Paros block
Tu t'assieds face à face avec	You are seated face to face with all
tous ces héros.	these heroes.
Et là, devant tes yeux qui	And there before your eyes that
jamais ne défaillent,	never flinch
Ces ombres, qui seront bronze	The shadows that will become
et marbre, tressaillent.	bronze and marble quiver.
L'avenir est à toi, ce but de	The future is yours, that goal of all
tous leurs voeux,	their wishes
Et tu peux le donner, ô maître,	And, oh master! you can give it to
à qui tu veux![28]	whom you wish!

By 1841, when Hugo was elected to the Académie française after three unsuccessful attempts, he had become the most famous French writer of his time. In 1843, a drama, *Les Burgraves*, described by Honoré de Balzac (1799–1850) as an "Italian painting on a mud wall,"[29] was an utter failure, closing after thirty performances at the Comédie française. His work now took on a different cast as his career was about to shift its focus to politics.

A tragedy, the accidental drowning of his daughter Léopoldine, turned Hugo's private life into a shambles. He mourned her for the rest of his life. The civic figure nevertheless sought all manner of diversion, continuing an active public life peppered by notorious and promiscuous love affairs and sundry debaucheries.

By then Hugo was writing very little, as his political activities came to preoccupy him. In 1845 he was elevated to the Chamber of Peers. The views he expressed there in the revolutionary year of 1848 were far less radical than tradition would have us believe, however. According to Graham Robb's biography, his role in the so-called June days, the brief and bloody civil war that gripped Paris from June 23 to 26,[30] marked a turning point that was to culminate in the central act of Hugo's life, his exile, three years later.

On December 2, 1851, Louis-Napoléon Bonaparte, who was constitutionally barred from succeeding himself as president of France, declared himself emperor.[31] Hugo, who had been one of Louis-Napoléon Bonaparte's initial supporters in 1848, now chose to leave France and went into exile, first in Brussels and then on the island of Jersey off the coast of Normandy, where he used his pen to attack the new regime and its propaganda machine.

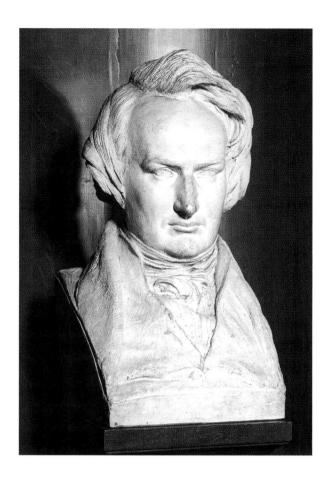

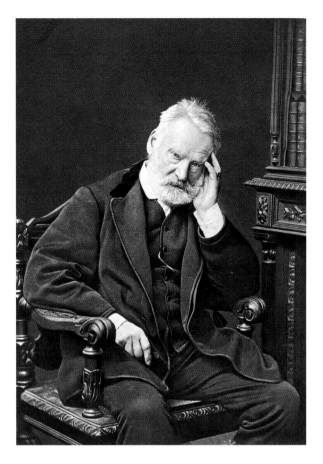

Figure 9

PIERRE JEAN DAVID
D'ANGERS

France, 1759–1856

Bust of Victor Hugo

1837

Plaster

Paris, Maison de Victor Hugo

Photo: © Photo Bulloz

Figure 10

PIERRE PETIT

*Victor Hugo at the Beginning
of His Exile, Brussels, 1861*

Photograph

Photo: © Bibliothèque Nationale de
France

Hugo grew to loathe Napoleon III, as Bonaparte fashioned himself, and his authoritarian Second Empire, in which civil liberties were suppressed, opponents exiled, and plebiscites used in a demagogical way to ratify decisions that had been made in high places. Hugo's volume of poetry *Les Châtiments* (Chastisements; 1853) – the center muse of Rodin's 1890 version of the monument, which he characterized as *La Justice vengeresse* (Vengeful justice)[32] – was published in two versions in November 1853, both printed in Brussels.

The poems of *Les Châtiments* were a turning point in Hugo's exile. A mutilated version with publication falsely attributed to Geneva and New York was officially distributed in Brussels. Another version, unexpurgated, in a smaller format, was smuggled from Belgium, England, and Jersey into France, where it was banned. It constituted one of the most ferocious and effective literary attacks ever launched against a political regime. In his *Cahiers* (Notebooks) Barrès recounts how Hugo's entourage believed that in a perverse way Napoleon III had provoked him into writing *Les Châtiments*,

a work meant to topple his regime. Doubtless this vengeful gesture remained in the popular consciousness in the first year of Rodin's commission, and its spirit seemed essential for a true representation of Hugo.

The French government, deeply embarrassed by Hugo's assaults, protested to the British government. On October 27, 1855, the British expelled Hugo from Jersey. On October 31 he sailed to Guernsey,[33] an island somewhat farther from the French mainland, where he was welcomed.

According to Paul Meurice (1820–1905), a companion of his exile, after six or seven months on Guernsey Hugo discovered that he had attained a total command of his art and that "verses obeyed him."[34] He controlled all registers and tones of what may be termed the literary and linguistic enterprise. Henceforth his prose and poetry combined lyrical and melodious verses with heroic epics, historical narratives with romances, comic raillery and buffoonery with the sublime. Furthermore, during the years of his exile he wrote his most remarkable works at a stunning rate and pace; *Les Contemplations* (Contemplations, 1856), *La Légende des siècles* (Legend of centuries, 1859), *Les Misérables* (1862), *Les Chansons des rues et des bois* (Songs of streets and woods, 1865), *Les Travailleurs de la mer* (The toilers of the sea, 1866), and *L'Homme qui rit* (The man who laughs, 1869) are but some of his best-known titles. The posthumous books, *Dieu* (God) and *La Fin de Satan* (The end of Satan), were also composed during these years, as were many works published later and well into the twentieth century.

The first publication of his Guernsey exile, *Les Contemplations*, generally thought to be his finest volume of poetry – it is also one of the finest volumes in all of French poetry – is a memorial in which the poet's life is reviewed in the perspective of his daughter's drowning. The preface provides a guide for readers: "We should read this book as the book of someone who is dead …. It begins with a smile, continues with a sob, and ends with the bugle call of the abyss [*Ce livre doit être lu comme on lirait le livre d'un mort …. Cela commence par un sourire, continue par un sanglot, et finit par un bruit du clairon de l'abîme*]." Part I, "Autrefois (1830–1843)" (Before), is an elegy that encompasses Léopoldine's life up to the day of her death. Part II, "Aujourd'hui (1843–1855)" (Today), describes the narrator's life in mourning, a life made up of chaos, murmurs, dreams, conflicts, delight, work, anguish, silence, and sacrifice, progressing to resignation and the contemplation of the divine.

One of the puzzles about Rodin's *Monument to Victor Hugo* concerns the metamorphosis of the muses and their eventual erasure from subsequent,

albeit unfinished, versions. *Les Contemplations* may provide a clue. Is it plausible to consider the two allegorical figures of the Rodin monument shown in this exhibit, Meditation, the muse standing on Hugo's left, and the Tragic Muse, standing on his right, as plastic correlatives not only of the dual structure of this poetic requiem but also of some of its themes?

There is, of course, an actual monument within the volume's pages. One of the poems, "Claire P.," is a memorial to Juliette Drouet's daughter, Claire Pradier, in which her father, James Pradier, imagines how he might have shaped her statue:

Et je ferai venir du marbre de Carrare.	And I shall have some marble brought from Carrare
Ce bloc prendra sa forme éblouissante et rare;	The shape of the slab will be dazzling and rare.
[...]	[...]
Le marbre restera dans la montagne blanche,	The marble remains in the white mountain
Hélas! car c'est à l'heure où tout rit que tout penche;	Alas! All was laughter before the fall;
Car nos mains gardent mal tout ce qui nous est cher;	Our hands grasp loosely what was dear to us
Car celle qu'on croyait d'azur était de chair; ...[35]	And she whom we believed divine was made of flesh; ...

The Tragic Muse in Rodin's monument may be an allusion to what lies beyond this world. One of the insights Hugo gained from his Guernsey exile was that light – illumination in the mystic sense – could be attained only through darkness, by the transfiguration of death and mourning. Initially, perhaps, the sculptor chose the muses in order to personify all the great Hugo works. But the vision of Guernsey – the sea, all the novels, all the poems, and all the plays, not to speak of Hugo's remarkable drawings – was an almighty vision: "For the word is the Verb, and the Verb is God [*Car le mot c'est le Verbe, et le Verbe, c'est Dieu*]."[36] Its only possible effigy was the great man himself made into the Almighty. An unfinished fetish? A completed portion? A work of art? According to Rilke, with the years, like Hugo, "Rodin returned to this bending inward, to this intense listening to one's own depth. This is seen in the wonderful figure that he called 'La

Méditation,' and in the immemorable [*sic*] 'Voix Intérieure,' the most silent voice of Victor Hugo's songs, that stands on the monument of the poet almost hidden under the voice of wrath."[37] A solitude made visible, an art that ennobles, the dark current of genius? Perhaps a fragmentary, flawed work? Or there may be a pervasive theme in these two titanic beings. Their art animates the sacred values of their transcendent visions.

NOTES

I have translated Victor Hugo literally; my intention is to communicate accurate meaning rather than render poetic effects. I should like to thank Rachael Blackburn for her encouragement and enthusiasm; Hélène Pinet and the Musée Rodin in Paris for facilitating work in the museum; Mitch Tuchman for his careful reading of this essay; and Jane Roos for generously sharing her knowledge of Rodin's work.

1. Victor Hugo, preface, *Les Rayons et les ombres*, in *Oeuvres poétiques*, vol. 1 (Paris: Gallimard, Editions de la Pléiade, 1964), p. 1021.

2. Auguste Rodin, quoted in Henri-Charles-Étienne Dujardin-Beaumetz, *Entretiens avec Rodin* (Paris: n.p., 1913), p. 53.

3. Rodin's early biographers, Judith Clavel and Frederick Lawton, give the date of 1886 for the initiation of these plans. See Jane Mayo Roos, "Rodin, Hugo, and the Pantheon: Art and Politics in the Third Republic," Ph.D. diss, Columbia University, 1981. See also Ruth Butler, *Rodin: The Shape of Genius* (New Haven: Yale University Press, 1993), pp. 208, 532.

4. "Je donne cinquante mille francs aux pauvres. Je désire être porté au cimetière dans leur corbillard. Je refuse l'oraison de toutes les églises; je demande une prière à toutes les âmes. Je crois en Dieu." Quoted in "La Mort et les funérailles de Victor Hugo," in *Actes et paroles*, vol. 4, ed. Paul Meurice and Auguste Vacquerie (1889), reprinted in *Oeuvres complètes de Victor Hugo*, vols. 15–16, ed. Jean Massin (Paris: Le Club français du livre, 1968), p. 951. This work and Avner Ben-Amos, "Les Funérailles de Victor Hugo," *Les Lieux de mémoire I* (Paris: Gallimard, 1984) are the sources of most of the details about the funeral described herein.

5. Maurice Barrès, *Le Roman de l'énergie nationale Les Deracinés* (1897), in *Romans et voyages* (Paris: Robert Laffont, 1994), p. 727.

6. "A ce qu'il paraît, la nuit qui a précédé l'enterrement d'Hugo cette nuit de veille désolée d'un peuple, a été célébrée par une copulation énorme, par une priapée de toutes les femmes de bordel en congé coïtant avec les *quelconques* sur les pelouses des Champs-Élysées, – mariages républicains que la bonne police a respectés." Edmond and Jules de Goncourt, *Journal: Mémoires de la vie littéraire*, vol. 3, 1879–90 (Paris: Fasquelle and Flammarion, 1956), p. 459 (entry for 2 June 1885).

7. "Comme tous les cultes de la mort, ces funérailles exaltaient le sentiment de la vie. La grande idée que cette foule se faisait de ce cadavre, et qui disposait chacun à se trouver plus petit, charriait dans les veines une étrange ardeur. C'était beau comme les quais des grands ports, violent comme la marée trop odorante qui relève nos forces, nous remplit de désirs. Les bancs des Champs-Élysées, les ombres de ses bosquets furent jusqu'à l'aube une immense débauche. Paris fit sa nuit en plein air. C'eût été le chaos, si ce monde trouble n'avait eu son phare. – Une foire? Non, l'humanité autour d'un cercueil! ... Nuit du 31 mai 1885, nuit de vertiges, dissolue et pathétique, où Paris fut enténébré des vapeurs de son amour pour une relique.

Peut-être la grande ville cherchait-elle à réparer sa perte. Ces hommes, ces femmes avaient-ils quelque instinct de ces hasards brûlants d'où sort le génie? Combien de femmes se donnèrent alors à des amants, à des étrangers, avec une vraie furie d'être mères d'un immortel! Les enfants de Paris qui naquirent en février 1886, neuf mois après cette folie dont ils reçurent le dépôt, doivent être surveillés." Barrès, *Roman de l'énergie nationale*, p. 728.

8. "De l'Étoile au Panthéon, Victor Hugo, escorté par tous s'avance. De l'orgueil de la France il va au coeur de la France. C'est le génie de notre race qui se refoule en elle-même: après qu'il s'est répandu dans le monde, il revient à son centre; il va s'ajouter à la masse qui constitue notre tradition. De l'Arc où le poète fut l'hôte du César, nous l'accompagnons à l'Arche insubmersible où toutes les sortes de mérite se transforment en pensée pour devenir un nouvel excitant de l'énergie française." Barrès, ibid., pp. 736–37.

9. The term used by Barrès, ibid., p. 736.

10 "La première fois que je vis Victor Hugo, il me fit une impression profonde; l'oeil était magnifique; il me parut terrible; il était probablement sous l'influence d'une pensée de colère ou de lutte, car son expression naturelle était d'un homme bon. Je crus voir un Jupiter français; quand je l'ai mieux connu, il me parut tenir plus de l'Hercule que du Jupiter." Dujardin-Beaumetz, *Entretiens avec Rodin*, p. 108.

11. "Il m'a raconté comment il a fait le buste de Hugo: 'Mme Drouet qui me connaissait a parlé de moi à son "mari." Il s'est mis en colère à l'idée de poser et a dit: Qu'il vienne me voir tant qu'il voudra, je ne poserai pas, je ne veux même pas voir de crayon. Alors je venais déjeuner, dîner. Il me disait: 'Bonjour, monsieur Rodin', sans plus. C'est extraordinaire le mépris qu'il avait pour moi. Je faisais mes croquis comme je pouvais. Et puis après ses repas, quand il sommeillait, je m'avançais et je prenais mes mesures." Maurice Barrès, *Mes Cahiers 1896–1923* (Paris: Librairie Plon, 1994), p. 264 (entry for 1905, probably October).

12. *Oeuvres complètes de Victor Hugo*, vol. 15–16, p. 1077.

13. "Dans l'après-midi, Bracquemond m'emmène visiter le sculpteur Rodin. C'est un homme aux traits de peuple, au nez en chair, aux yeux clairs, clignotant sous des paupières maladivement rouges, à la longue barbe flave, aux cheveux coupés courts et rebroussés, à la tête ronde, la tête du doux et obstiné entêtement, – un homme tel que je me figure physiquement les disciples de Jésus-Christ." Goncourt, *Journal*, vol. 3, p. 562 (entry for 17 April 1886).

14. "Je travaillais des heures entières dans la vérandah de l'hôtel rempli de fleurs et de plantes vertes." Dujardin-Beaumetz, *Entretiens avec Rodin*, pp. 108–09.

15. Ibid., p. 108.

16. "Il s'étend ensuite longuement sur le buste de Hugo, qui n'a pas posé, mais qui l'a laissé venir à lui autant qu'il a voulu; et il a fait du grand poète un tas de croquetons – je crois soixante – à droite, à gauche, à vol d'oiseau, mais presque tous en raccourci, dans des attitudes de méditation ou de lecture, croquetons avec lesquels il a été contraint de construire son buste." Goncourt, *Journal*, vol. 3, p. 734 (entry for 29 December 1887).

17. "J'ai eu le phénomène bizarre d'une brusque éclipse de mémoire. Cela a duré environ deux heures." Victor Hugo, *Pierres*, ed. Henri Guillemin (Geneva: Éditions du milieu du monde, 1951), p. 52.

18. The date of the poem is 1855. See *Les Contemplations*, in *Oeuvres poétiques*, vol. 2 (Paris: Gallimard, Editions de la Pléiade, 1976), pp. 692–93.

19. Jean-Pierre Richard," Hugo," in *Études sur le romantisme* (Paris: Éditions du Seuil, 1970), p. 177.

20. Viscount François-Auguste-René de Chateaubriand (1769–1848), whose memoirs, *Mémoires d'outre-tombe* (Memoirs from beyond the grave, 1850), have proved to be his most lasting work, was the French author with the greatest prestige, both literary and political, in the first decade and a half of the nineteenth century.

21. Cited by Jean-Bertrand Barrère in *Victor Hugo: L'Homme et l'oeuvre* (Paris: Hatier, 1967), p. 13.

22. "J'ignore dans quel monde Victor Hugo a mangé préalablement le dictionnaire de la langue qu'il était appelé à parler; mais je vois que le lexique français, en sortant de sa bouche, est devenu un monde, un univers coloré, mélodieux et mouvant." Charles Baudelaire, "Sur mes contemporains," in *Oeuvres complètes*, vol. 2 (Paris: Gallimard, Editions de la Pléiade, 1976), p. 133.

23. Gustave Larroumet, *Courrier de l'art*, quoted in Butler, *Rodin*, p. 241.

24. See Graham Robb's splendid *Victor Hugo: A Biography* (New York: W.W. Norton, 1998), pp. 181–82, 187–88, 305.

25. For example, see her letter to Hugo of 14 September 1853: "When it comes to your devilry, I sense this pastime is dangerous for sanity if it is serious, and I have doubt this is so on your part. If it is tinged with deceit, then it is blasphemous. [*Quant à vos diableries ... je sens que ce passe-temps a quelque chose de dangereux pour la raison, s'il est sérieux, comme je n'en doute pas de ta part, et d'impie, pour peu qu'il s'y mêle la moindre supercherie.*]" in Hugo, *Oeuvres complètes*, vol. 9, ed. Jean Massin (Paris: Le Club français du livre, 1968), p. 1107.

26. Victor Hugo, "A M. David, Statuaire" (To Mr. David, sculptor), in *Les Feuilles d'automne*, in Hugo, *Oeuvres poétiques*, vol. 1, pp. 733–34.

27. The phrase is the one used by Rainer Maria Rilke in *Auguste Rodin* (New York: Sunwise Turn, 1919), p. 59.

28. Victor Hugo, "Au statuaire David" (For the sculptor David), part 4, in *Les Rayons et les ombres*, in *Oeuvres poétiques*, vol. 1, p. 1072.

29. Barrère, *Hugo*, p. 120.

30. This was a spontaneous protest in which workers cut from government payrolls were joined by students, artisans, and employed workers. See Robb, *Hugo*, pp. 263 ff.

31. He was Napoleon's nephew, the third son of Louis Bonaparte, Napoleon's brother, and his wife, Hortense de Beauharnais Bonaparte, Napoleon's stepdaughter.

32. See Jane Roos, "Rodin's *Monument to Victor Hugo*," *Art Bulletin* 68, no. 4 (December 1986), pp. 644–45.

33. Rodin himself made a pilgrimage to Guernsey in connection with his monument.

34. Barrès, *Mes Cahiers*, p. 192 (entry for 22 December 1903).

35 Victor Hugo, "Claire P.," in *Les Contemplations* in *Oeuvres poétiques*, vol. 2, p. 698.

36. Victor Hugo, "Réponse à un acte d'accusation," ibid., vol. 1, p. 503.

37. Rilke, *Rodin*, p. 38.

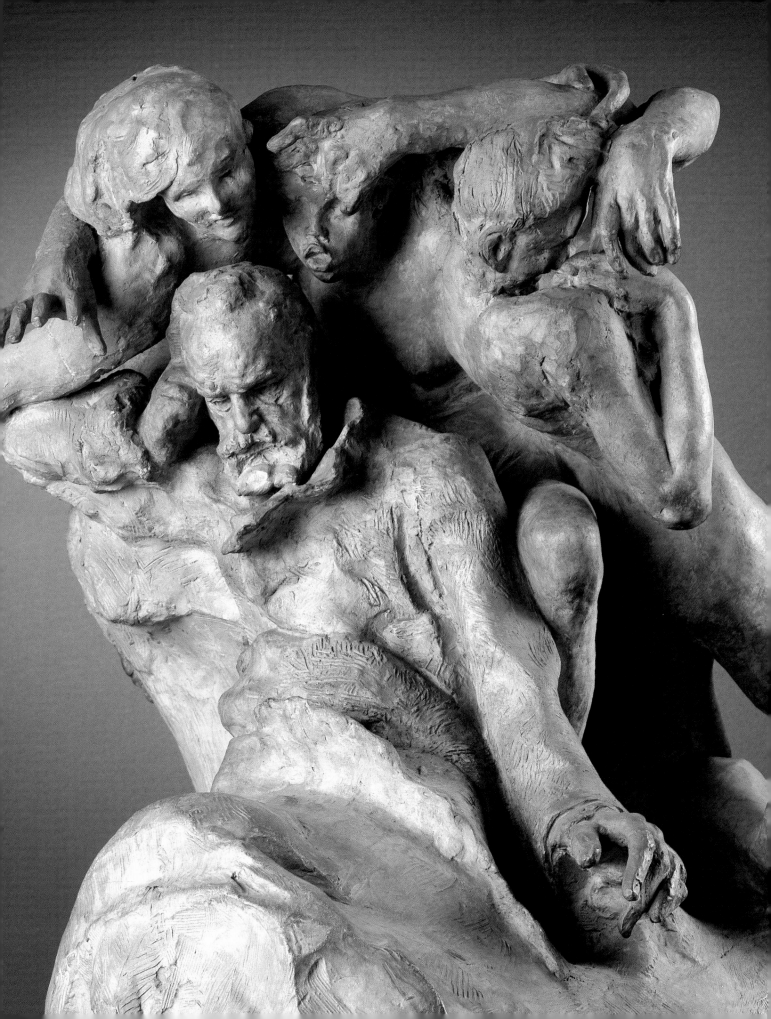

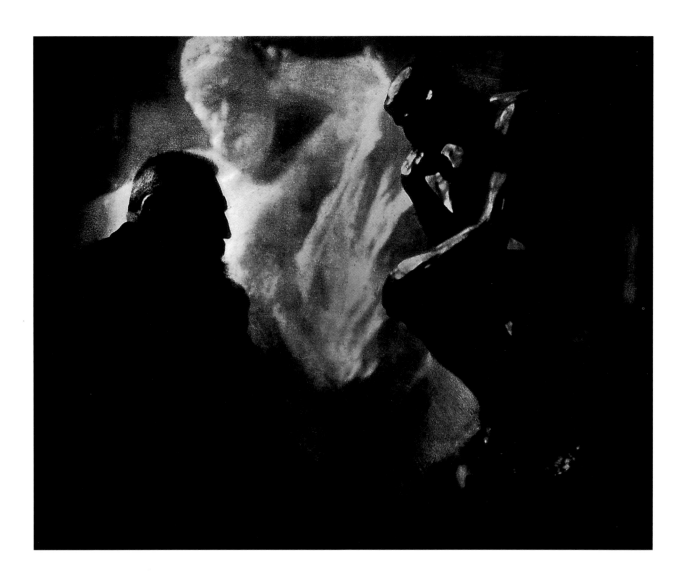

Figure 11 [catalogue no. 23]
EDWARD STEICHEN
United States, 1879–1973

Portrait of Rodin with The Thinker and The Monument to Victor Hugo

1902
Toned silver print
13¼ × 16⅝ in. (33.7 × 42.2 cm)
Iris and B. Gerald Cantor Foundation
(Photo by Frank Wing)

Steichen's Choice

JANE MAYO ROOS

In the summer of 1901 Edward Steichen bicycled from Paris to the nearby suburb of Meudon to see the man he regarded as one of the most important artists alive. Auguste Rodin was then in this sixty-first year and had survived decades of controversy as the maker of profoundly original sculptures; Steichen (1879–1973) was twenty-two, just beginning his career as a photographer and recently arrived from the States. In those dawn-of-the-century days, when bicycles held everyone in thrall, Steichen's visit to Rodin was a sporty, machine-age version of the old-fashioned pilgrimage trek: an exuberant journey *en vélo* to pay homage to one of the heroes of modernist art. After dinner Rodin leafed through the photographer's portfolio, "pausing now and then to look at one for some time, and giving grunts of approval and, sometimes, words." As Steichen remembered it, he then reached out his hands to the sculptor: "Master," he said in a youthful rush, "one of the great ambitions of my life is to make a photograph of you."[1]

Rodin welcomed the request, and for nearly a year Steichen spent most of his Saturday afternoons studying the man and his works. When the time came to photograph Rodin, in his studio in Paris, Steichen posed the sculptor in front of *The Monument to Victor Hugo*. Wanting to include *The Thinker* (1880) but lacking a wide-angle lens, Steichen shot *The Thinker* on a second plate and then set about devising the techniques for combining two negatives (figure 11).

The conjunction of Rodin, *The Thinker*, and *The Monument to Victor Hugo* is a brilliant conceit, some said "the finest photograph ever taken."[2] Within the image the sculptor and his creations fold into one another with the near-seamless slippage of contiguous motion-picture frames. The visual connections among the three elements – all are male figures, hand-to-head and engaged in thought – play against their differences: the flesh of Rodin in profile, the bronze of *The Thinker* turned slightly toward the viewer, and the full-front plaster of Hugo behind and above them both. Shadow plays against light, as it does so significantly in Rodin's works, and solid form seems to materialize outward from each of "the thinkers'" brows. All are in some sense "outsiders": the *Monument to Victor Hugo* depicts the poet during the years of his exile from France, and the isolated figure of *The Thinker* emerged from *The Gates of Hell* (1880–c. 1900), where he sat on a ledge, the creator, the observer, of all the turmoil around him. As for Rodin, he was always slightly removed from the tight interconnectedness of the Parisian art establishment because of his background in commercial art and because of the stark

individualism of his works. This was particularly true of Rodin's situation in the years preceding Steichen's photograph.

Steichen's *hommage* to Rodin is a carefully crafted image, premeditated and contrived: two negatives were set together, and the left-hand negative was printed in reverse.[3] To a twentieth-century audience it might seem peculiar that, after so carefully studying Rodin, Steichen chose *The Monument to Victor Hugo* – out of all the works that then crowded Rodin's studio – as a sculpture that epitomized Rodin and his *oeuvre*. The monument is not one of the works most familiar to us today and carries none of the instant recognition of *The Thinker*, say, or *The Kiss* (1886), *The Monument to Balzac* (c. 1897) or *The Burghers of Calais* (1884–88). Why Steichen chose as he did and why we are so ignorant of the monument today have everything to do with the story this essay is about to tell.

Victor Hugo

Rodin's acquaintance with Hugo began in the early 1880s, when, like Steichen, he sought permission to render the portrait of a man he greatly esteemed. In those years Hugo was at the zenith of his popularity, venerated by the public as the living embodiment of French genius, treasured by the nation as a grandfatherly creator whose life and works had spanned the century, and lionized by French republicans as a political activist who had spent long years in exile rather than bow to the will of Napoleon III. Hugo had begun to publish while still in his teens, and the astonishing range and variety of his writings quickly established him as the preeminent writer in France. He had become a public figure as well, active in politics by the mid-1840s and a participant in the National Assembly created by the Second Republic in 1848.

Then, in December 1851, Louis-Napoléon, president of the Second Republic, dissolved the assembly, imprisoned thousands of his political critics, and seized for himself many of the functions of government. A year later he terminated the Republic and made himself Napoleon III, emperor for life. Hugo participated in the demonstrations that followed the *coup d'état*, and in danger of imprisonment he fled France at the end of 1851. After a brief stay in Brussels, he moved to the Channel Islands, a group of rugged little outcrops that belonged to England but lay off the Normandy coast (figure 12). Settling first on Jersey, then on Guernsey, he remained on the Channel Islands throughout the rule of the man he despised as "Napoléon le petit."[4]

Figure 12

ALPHONSE MONCHABLON

Victor Hugo on the Channel Islands

no date

© Bibliothèque Nationale de France

Though given amnesty in 1859, Hugo refused to return to France, in protest against the usurpation of power with which the Empire had begun: "I shall share the exile of freedom to the end. When freedom returns, so shall I."[5] He persisted in his indictment of the government he loathed, and for many in France he came to represent a pure and courageous political conscience railing against the empty spectacle of the Second Empire: "That flame on a rock, that beacon in a storm, they are enough: it is certain that the night will not be eternal."[6] On Jersey he wrote *Les Châtiments* (Chastisements 1853), a volume of political verse that excoriated Napoleon III, the target of the "castigations" of the book's title. "I hold the red-hot iron," he addressed the emperor, "and I see your flesh smolder and fume."[7] And from Guernsey he published a collection of lyric poetry, *Les Contemplations (*1855), and then his vast novel of social morality, the instantly and ever popular *Les Misérables* (1862).

The Second Empire fell in 1870. Napoleon III had embroiled the nation in a war with Prussia, a war it was clear from the outset that France could not win. Captured on September 1, Napoleon III was forced to abdicate, and in the turmoil of war a republican government was declared. Hugo immediately began his journey home. The fighting was over by January 1871, when the siege of Paris was lifted and Prussia was declared the victorious power.

However, the period that Hugo would chronicle as *L'Année terrible* (1872) had only begun. Worse than the war with the Prussians – worse than the lives lost in fighting a foreign invasion and worse than the humiliation of defeat – was the civil war that ensued and lasted from March to May of 1871 (figures 13–15). In the final week of the Commune, as the civil war is called, some twenty thousand people died on the barricades fighting in Paris, slain during that *semaine sanglante* (bloody week) by their fellow citizens of France. More lives were lost during the Commune than during the Reign of Terror in the eighteenth century.[8]

Shocked by the Franco-Prussian War and traumatized by the Commune, France turned cautious and conservative in the Third Republic's early years. In the National Assembly monarchist politicians dominated both houses, and at the head of the country for much of the decade was the militaristic *maréchal* Patrice MacMahon, who designated his administration the "government of the moral order." Political tensions were fierce, and pitted against the monarchists were the more liberal republican forces. The balance of power shifted in 1879, when the monarchists lost control of the parliament and France acquired, at last, "a republic of republicans."

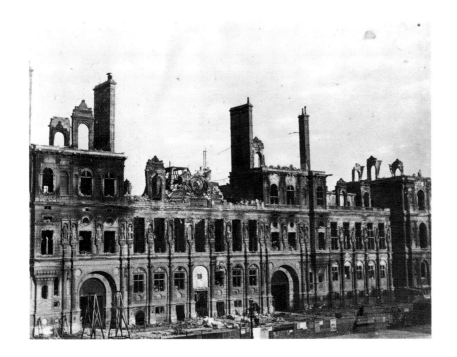

Figure 13

AUGUSTE BRAQUEHAIS

Hôtel de Ville, Paris, May 1871

Photograph

© Bibliothèque Nationale de France

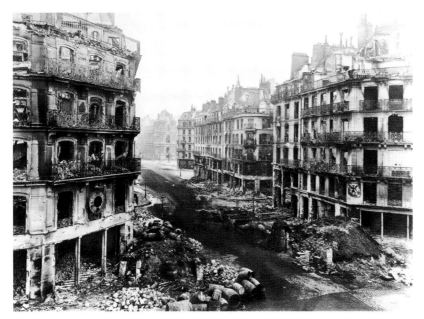

Figure 14

AUGUSTE BRAQUEHAIS

Rue de Rivoli, Paris, May 1871

Photograph

© Bibliothèque Nationale de France

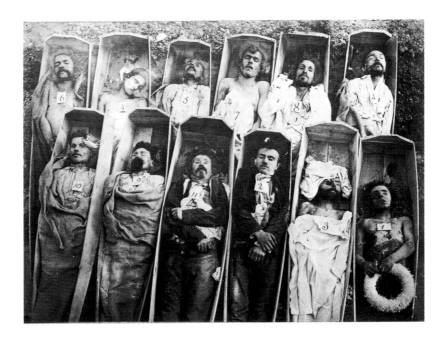

Figure 15

ADOLPHE-EUGÈNE DISDÉRI

Cadavers of the Communards

1871

Photograph

© Bibliothèque Nationale de France

Hugo was elected to the Senate in 1876, but though he was passionately outspoken on such issues as amnesty for the Communards, his presence was regarded as more symbolic than real. He was now seventy-four, and he was viewed as a titanic and venerable patriarch, more like an Old Testament prophet, divinely inspired and returned from the grave, than a nuts-and-bolts politician of the new era.

In February 1881 Hugo turned seventy-nine, and a vast celebration was orchestrated to commemorate the beginning of his eightieth year. It is no exaggeration to say that the atrocities of 1871 and the decade of conflict that followed had created a need for binding national symbols, reassuring communal myths, and that the cult of Victor Hugo arose and expanded to fill the country's needs. Except for the most strongly alienated *hugophobes*, everyone, it seemed, could join the festivities and honor the man who was the country's greatest living writer and nearly as old as the century itself. On the afternoon of February 27 more than half a million people passed before Hugo's house on the avenue d'Eylau, in "the longest procession seen in Paris since the days of Napoleon Bonaparte."[9] One newspaper commented that "for a day, politics kept silent"; and another, that "celebrations like this have the effect of cementing national unity."[10]

This was the climate in which Rodin's first contact with Hugo occurred.

Auguste Rodin

Rodin in the 1880s was an artist of relatively untried and unproven abilities. Born in 1840, he had spent most of his career working as a commercial sculptor, modeling designs for large and small decorative projects that other artists often signed. In the 1850s he was rejected three times for admission to the École des beaux-arts, the prestigious, government-funded training school that prepared artists for careers in the fine arts. In his off-hours he produced more serious work, but his first submission to the Salon, the yearly exhibition of fine arts that was the most important venue for contemporary artists and the *sine qua non* for critical and popular success, was rejected by the jury in 1865.[11] He began to exhibit his sculpture at the Salon only when he reached his late thirties.

His most significant works to date were the life-sized *Age of Bronze* (1875–76; figure 16), the extreme naturalism of which stripped the figure of its expected imaginative envelope and incurred the charge that Rodin had cast the figure from life, and his *John the Baptist Preaching* (1878), another single-figured work, which he had modeled on a larger scale to prove to the public that the power of his figures came from his abilities and not from the direct casting of the model's body.[12]

In 1880, under the liberal administration of Edmond Turquet (1836–1914), Rodin was commissioned to execute the work that became his *Gates of Hell* (figure 17). In her biography of Rodin, Ruth Butler has raised the interesting, and extremely significant, issue of how unusual it was for an artist of Rodin's background – an artist with no credentials as a monumental sculptor – to be handed a large commission from the state. In her analysis national and administrative politics played a major role in the choice of Rodin. When the staunchly republican Turquet arrived at the ministry of fine arts,[13] he was determined to bring new life into the administration and to redress the grievances that had festered under the ultraconservative, moral-order government. In those years the administration had been run by Philippe, marquis de Chennevières (1820–1899), who held the key position of director of fine arts. Technically the fine-arts agencies were headed by a cabinet minister, but he was essentially a politician – in some sense, a figurehead – who often had little experience in the arts. In practice, it was the director of fine arts who managed the ministry's offices and for all intents and purposes established the country's fine-arts policy. Chennevières became director of fine arts after a long career in museum administration, but he was a man ill-suited to the changing ethos of the times: he hated the modern

Figure 16
AUGUSTE RODIN
France, 1840–1917

The Age of Bronze
1875–76
Bronze
67 × 23⅝ × 23⅝ in.
(175.3 × 59.9 × 59.9 cm)
Foundry: Alexis Rudier
Iris and B. Gerald Cantor Center for Visual Arts at Stanford University, Gift of B. Gerald Cantor Collection

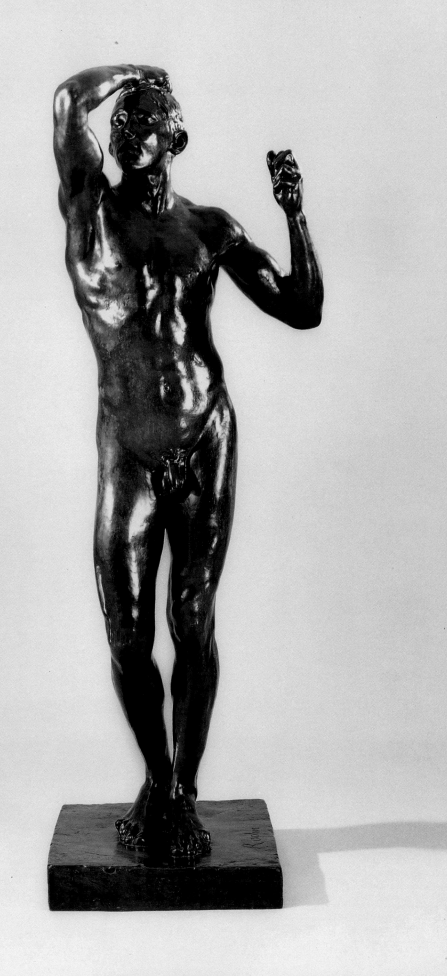

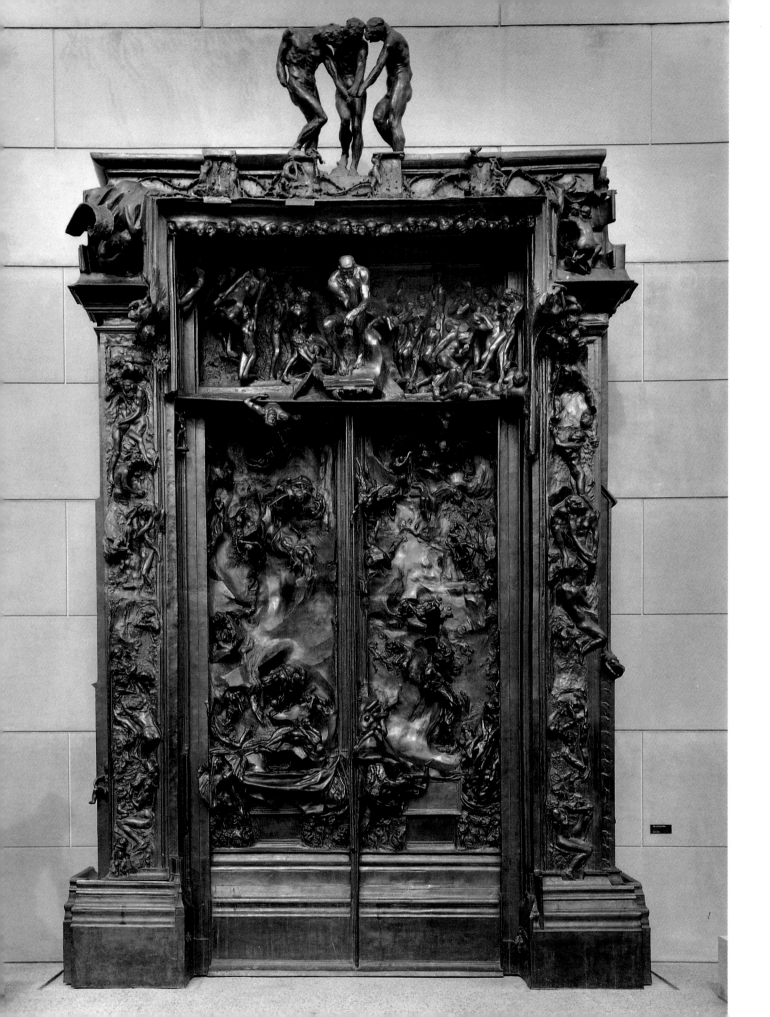

Figure 18
AUGUSTE RODIN
France, 1840–1917

Croquis (Rough Sketches) of Victor Hugo

c. 1883
Pen and black ink on paper
8⅛ × 6 in. (20.7 × 15.2 cm)
Paris, Musée Rodin
Photo: © Musée Rodin

Figure 17
AUGUSTE RODIN
France, 1840–1917

The Gates of Hell

1880–c. 1900
Musée Rodin cast no. 5/12, 1977
Bronze
250¾ × 158 × 33⅜ in.
(636.9 × 401.3 × 84.6 cm)
Foundry: Coubertin
Iris and B. Gerald Cantor Center for
Visual Arts at Stanford University,
Gift of the B. Gerald Cantor
Collection
(Photo by Frank Wing)

world, loathed democracy in any form, and believed fanatically in the principles of hierarchy and privilege.

When Turquet entered the government, he immediately liberalized the regulations for the Salon, the elitism of which had alienated so many painters when Chennevières was in power, and compensated Rodin for the callous treatment he had received from Chennevières in regard to *The Age of Bronze*. In 1880 Turquet purchased the plaster for the government and ordered a bronze cast, and in the same year he awarded Rodin the commission for *The Gates of Hell*. That the portal was designated for a state museum of decorative arts, that the museum had been a pet project of Chennevières, and that Turquet gave the commission to Rodin, an artist who represented just the sort of modernist individualism that Chennevières despised, meant that Turquet could play power politics on several levels at once.[14]

In the Salons of the early 1880s Rodin exhibited a large plaster for the figure of *Adam* (Salon of 1881) from *The Gates of Hell* and a series of portraits of the artists and friends around him (see figure 19). However, that Rodin the "outsider," a man who came to "high art" not through the conventional channels but via the commercial arts, had been shown such favoritism by the new and liberal government did not endear him to the ever powerful and conservative establishment.

Rodin's Portrait of Victor Hugo

As Rodin recalled, "The first time I saw Victor Hugo, he made a profound impression on me; his eyes were magnificent ... I thought I had seen a French Jupiter."[15] Hugo, however, was neither as generous nor as welcoming as Rodin would be to Steichen at Meudon. He had suffered a stroke in 1878, after which he was cosseted and protected by his entourage in an environment that some said resembled the court of Louis XIV. Besieged by painters and sculptors, Hugo loathed the idea of posing for hours on end and, worse yet, winding up with a portrait that displeased him. So he allowed Rodin access to the household but refused to give formal sittings and insisted that Rodin keep his distance. In Rodin's words:

I worked entire hours in the veranda of the *hôtel* filled with flowers and green plants. I saw Victor Hugo sometimes, across the salon, cold and hard expression; he would also go and sit at the end of the room, absorbed in thought I placed myself beside or behind him, following him with my eye, making quick sketches of him [figure 18], drawing as many profiles as I could

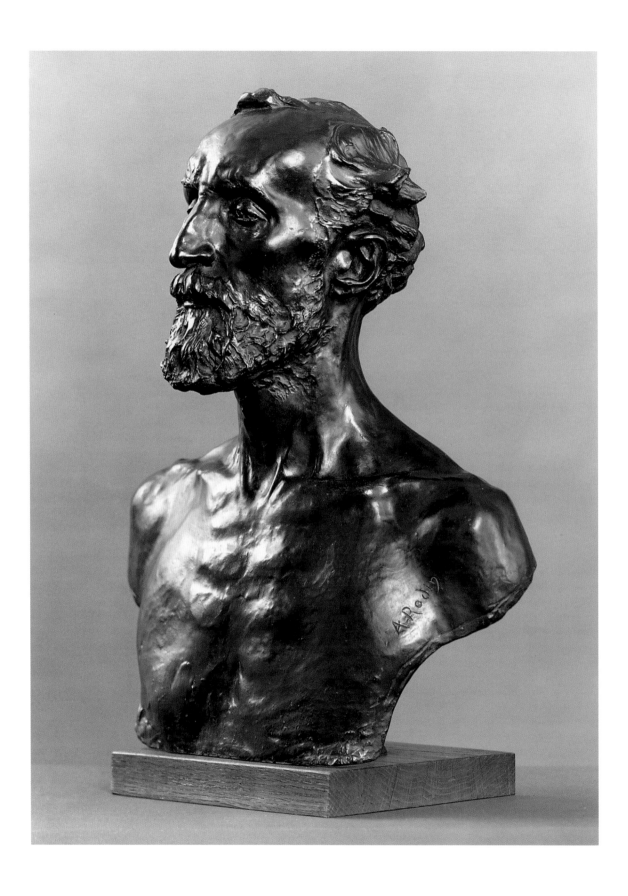

MORT DE VICTOR HUGO

HOTEL VICTOR HUGO

L'archevêque cherchant à attraper l'Âme du grand poète.

Figure 20

Caricature of Archbishop Guibert trying to catch the soul of Victor Hugo

no date

Photo: © Bibliothèque Nationale de France

Figure 19 [catalogue no. 20]

AUGUSTE RODIN

France, 1840–1917

Jules Dalou

1883, cast in 1925

Bronze

20¼ × 16 × 7 in.

(52.7 × 40.6 × 17.7 cm)

Inscribed on proper left shoulder front and on stamp inside: A. Rodin

Foundry mark on rear proper right shoulder: ALEXIS RUDIER/ Fondeur. PARIS

Bequest of Jules E. Mastbaum; Rodin Museum, Philadelphia

on little squares of paper; he didn't look at me, but had the goodness not to dismiss me; he tolerated me. I made many drawings of the skull; I then compared those contours with those of the bust; thus I managed to execute it, but with such difficulties. I extricated myself from them as best I could.[16]

The sketches in figure 18 bear out Rodin's description of working from rapid glimpses of Hugo on the move and shaping the portrait from a succession of contours of the skull. Studying Hugo's head from a multiplicity of points of view – bird's-eye, profile, three-quarters, and full face – Rodin did dozens of these drawings, sometimes using pen and black ink on translucent leaves of cigarette paper. "I would go and look at him, and then, with my head filled with the expression of an image which combined the properties of Pan, Hercules, and Jupiter, I would go back again to memorize a feature, a wrinkle or a fold of skin."[17]

In this way he finished the bust in 1883 (figures 21–22), but not apparently before "le Maître" had indeed evicted him. A series of related sculptures and drypoints followed (figures 23–27), Rodin's most ambitious experiments with the medium.[18] The bronze portrait was exhibited at the Salon of 1884, but however enthusiastic the critics were, "Jupiter" and his circle were reportedly not amused. Someone is said to have commented that the work looked like "the portrait of an old chiseler," and according to Edmond de Goncourt, Rodin's fatal error was to have rendered Hugo as the sculptor saw him and not according to the idealizing vision demanded and protected by Hugo's family.[19]

A year later Hugo became gravely ill, and a conflict erupted between his family and the Catholic Church. In May 1885 the archbishop of Paris wrote to the family and offered to pray at Hugo's bedside. Through Édouard Lockroy (1840–1913), a politician who had married into Hugo's household and now functioned as Hugo's spokesman, the poet's wishes were conveyed to the prelate: the archbishop had been kind, but Hugo had no desire to see a Catholic priest or the representative of any other cult. A freethinker and anticlerical in the last years of his life, Hugo would not in his last hours bend his views or bow to the will of the Church. The press and cartoonists followed the confrontation avidly – Hugo did little in secret during the last decades of his life – and the caricature in figure 20 satirizes the archbishop's attempt to seize upon Hugo's soul.

Hugo died on May 22, 1885, of pulmonary congestion. When his death was announced, the French parliament voted to give him a national funeral.

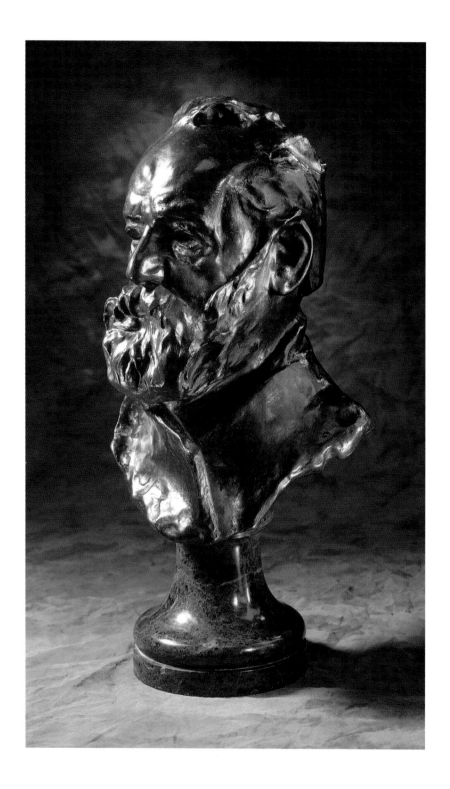

Figures 21–22 [catalogue no. 2]
AUGUSTE RODIN
France, 1840–1917

Bust of Victor Hugo

1883, date of cast unknown
Bronze
17 × 10¼ × 10¼ in.
(43.2 × 26 × 27.3 cm)
Inscribed on base, proper right:
A. Rodin
No foundry mark
Iris and B. Gerald Cantór Collection
(Photo by Steve Oliver)

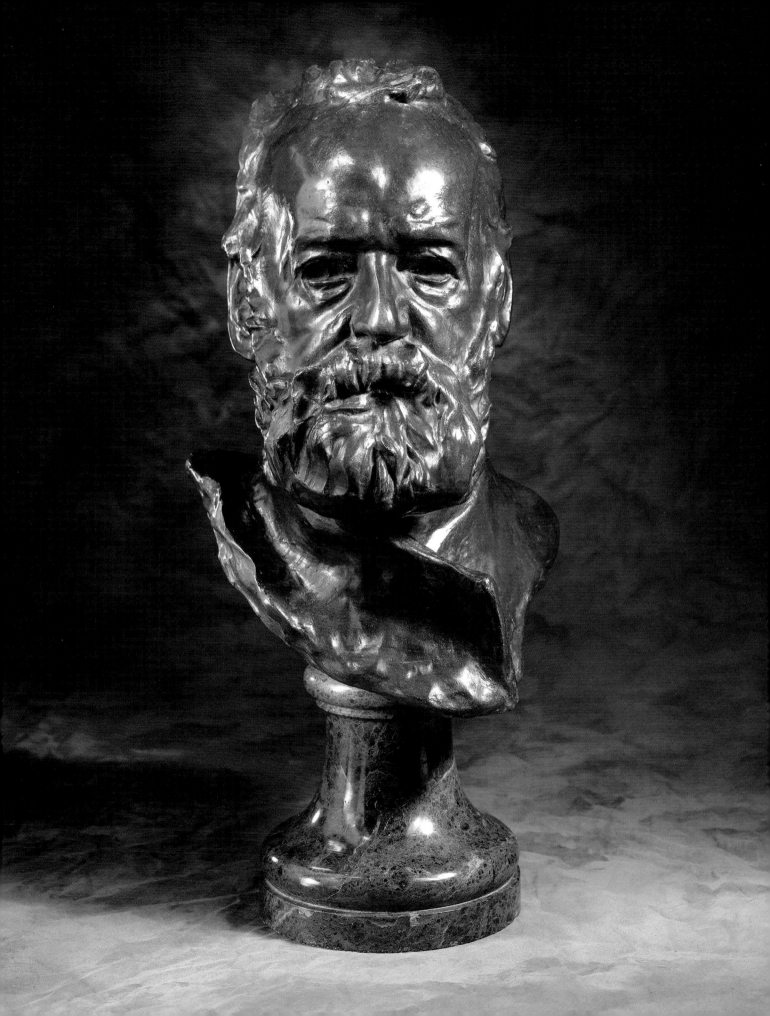

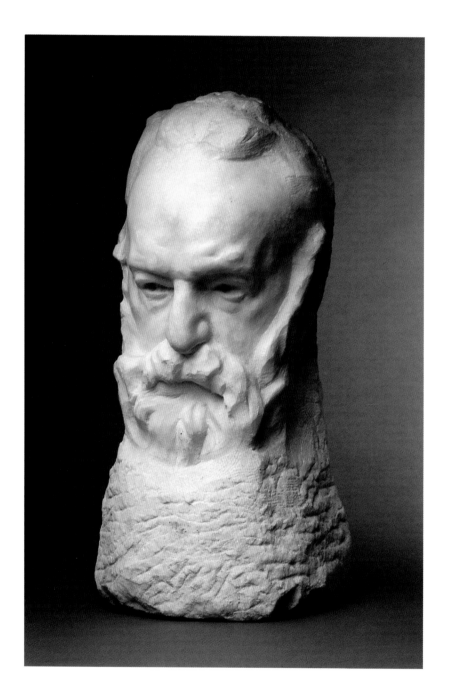

Figure 23 [catalogue no. 11]
AUGUSTE RODIN
France, 1840–1917

Head of Victor Hugo

no date
Marble
18¹/₂ × 8³/₈ × 7⁷/₈ in. (47 × 21 × 20 cm)
Paris, Musée Rodin
Photo: © Musée Rodin and
Bruno Jarret/ADAGP

Figure 24 [catalogue no. 1]
AUGUSTE RODIN
France, 1840-1917

Head of Victor Hugo

c. 1883
Terra-cotta
6³/₄ × 4³/₈ × 5³/₈ in.
(17.5 × 11 × 13.5 cm)
Paris, Musée Rodin
Photo: © Musée Rodin and
Adam Rzepka/ADAGP

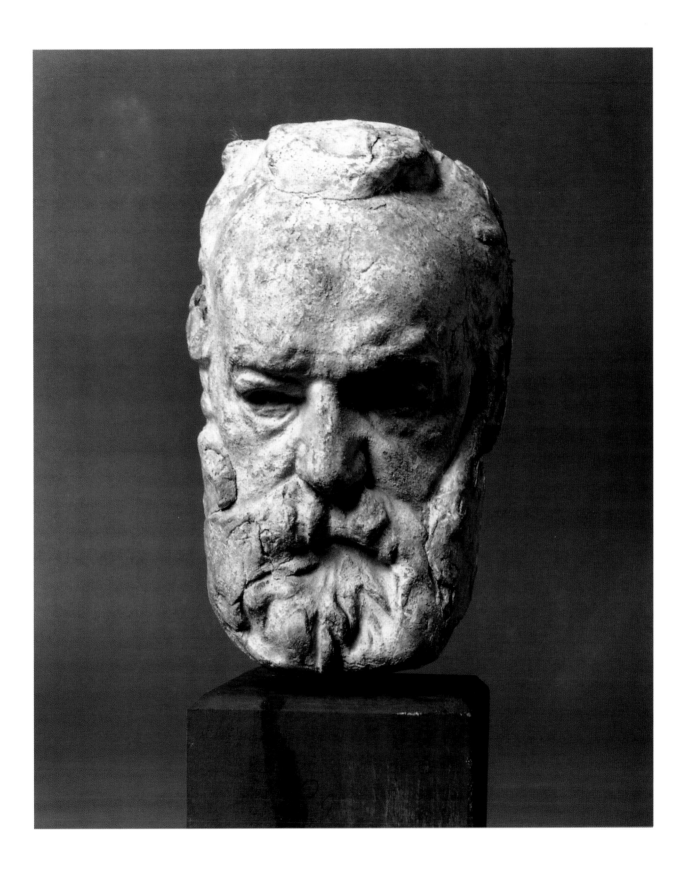

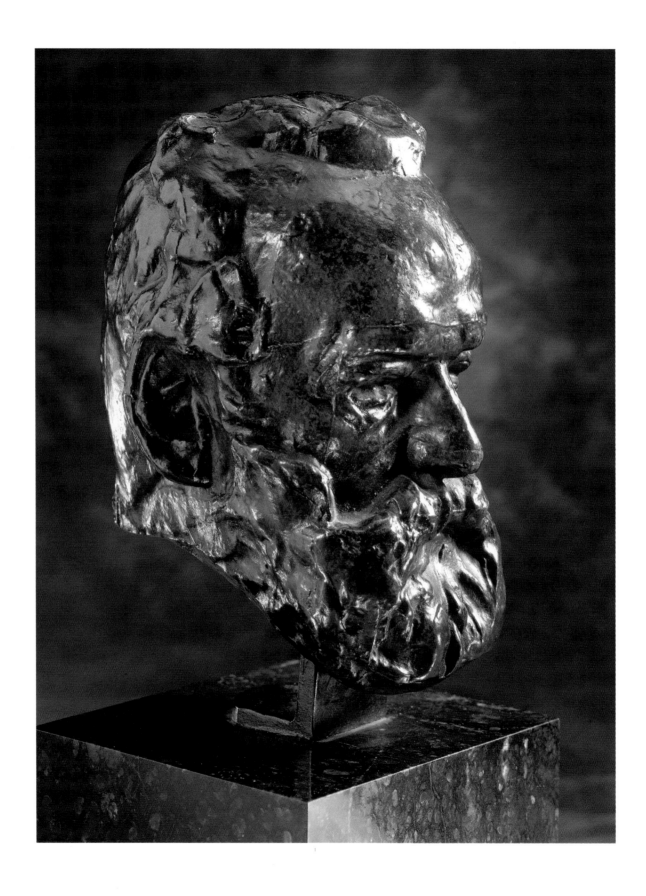

VICTOR HUGO

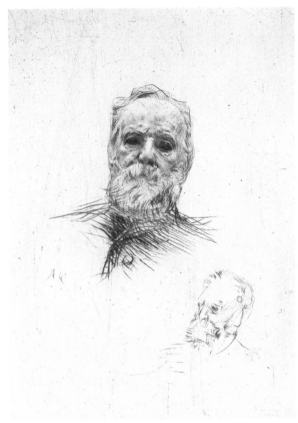

Figure 25 [catalogue no. 5]

AUGUSTE RODIN

France, 1840–1917

Head of Victor Hugo

1886, date of cast unknown

Bronze

7³⁄₄ × 4 × 5¹⁄₄ in.

(19.7 × 10.2 × 13.3 cm)

Inscribed on neck, proper left: A.
Rodin

Foundry mark on neck, proper right:
Alexis Rudier Fondeur

College of the Holy Cross, Worcester,
Massachusetts, Gift of Iris and B.
Gerald Cantor

(Photo by Steve Oliver)

Figure 26 [catalogue no. 3]

AUGUSTE RODIN

France, 1840–1917

Victor Hugo

1884

Drypoint

8³⁄₄ × 15¹⁵⁄₁₆ in. (22.2 × 40.5 cm)

Los Angeles County Museum of Art,
Gift of B. Gerald Cantor Foundation

(Photo by Steve Oliver)

Figure 27 [catalogue no. 4]

AUGUSTE RODIN

France, 1840–1917

Victor Hugo

1886

Drypoint

8³⁄₄ × 6¹⁄₂ in. (22.2 × 16.5 cm)

Iris and B. Gerald Cantor Foundation

(Photo by Steve Oliver)

The site they chose for burial was the highly controversial building that had variously served as the church of Sainte-Geneviève or the Pantheon. Because it would become the site designated for Rodin's *Monument to Victor Hugo*, some account of this extraordinary structure is due.

The Pantheon

The church of Sainte-Geneviève was built in the eighteenth century, on the montagne Sainte-Geneviève, in the fifth arrondissement of Paris (figures 28–29).[20] Designed by Jacques-Germain Soufflot, it was commissioned by Louis XV and dedicated to the patron saint of Paris. In 1791, on the death of the fiery Revolutionary orator Honoré-Gabriel Riqueti, comte de Mirabeau, the building was appropriated by the state and converted into a secular temple – a pantheon – to the nation's heroes. The building's lower windows were walled in, and the words AUX GRANDS HOMMES LA PATRIE RECONNAISSANTE were carved on the west pediment. The idea behind the creation of the Pantheon was to provide a kind of everyman's, nonecclesiastical alternative to Saint-Denis, the church north of Paris that had served as the burial place of kings.

Figure 28

Exterior of the Pantheon
1830
Engraving

Figure 29

Interior of the Pantheon
1823
Engraving

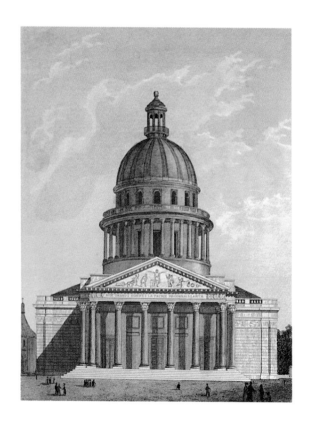

Figure 30

Caricature depicting Victor Hugo and the secularization of the Pantheon

no date

Photo: © Bibliothèque Nationale de France

By the dawn of the nineteenth century the building had, thus, acquired a double political significance: as the church of Sainte-Geneviève it commemorated the *ancien régime*, which is to say, the Bourbon monarchy and its partnership with Catholicism; and as the Pantheon it stood for republicanism and the separation of church and state. It was a sign with dual and mutually exclusive signifiers, and its status changed according to the political orientation of the governments that followed. Under the Bourbon Restoration (1815–30), when the monarchy reigned with the cooperation of the Catholic Church, the Pantheon was consecrated as the church of Sainte-Geneviève. Under the Second Republic in 1848, when revolutionary ideals resurfaced, the church of Sainte-Geneviève became the Pantheon. After the *coup d'état* the Pantheon became once again the church of Sainte-Geneviève.

The building remained a church through the conservative years of the 1870s, when the marquis de Chennevières initiated a large program of religious murals to decorate the structure's interior with images that would commemorate "the marvelous history of the Christian origins of France."[21] In the spirit of the moral-order government the program would conflate "religious and patriotic art," so that "all the subjects treated, all the figures represented [would] be marked by this double sign of being Christian and being French." To this phase of the program's decoration date the murals by Pierre Puvis de Chavannes (1824–1898) that depict the girlhood of Sainte Geneviève (figure 31) as well as the *Martyrdom of Saint Denis* (figure 32) by Léon Bonnat (1833–1922).

With the increasing liberalism of the early 1880s, politicians on the left – Édouard Lockroy at the forefront – began to pressure the government to appropriate the building and establish it as a Pantheon for yet another time. Hugo's death offered itself as the perfect moment to resecularize the church of Sainte-Geneviève and restore the building to its Revolutionary designation; as an avowed anticlerical Hugo would never have sanctioned a religious burial, and, given his controversy with the Catholic Church, they would never have agreed to receive his remains in a consecrated space. So, immediately following Hugo's death, the building was deconsecrated, "disinfected" of religious superstition according to the caricature in figure 30. As Jeanine Plottel has described, the Pantheon became the terminus for the greatest funeral that France had ever seen (figure 33).

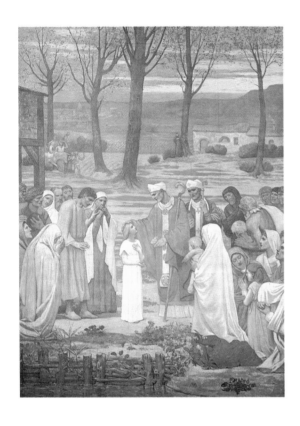

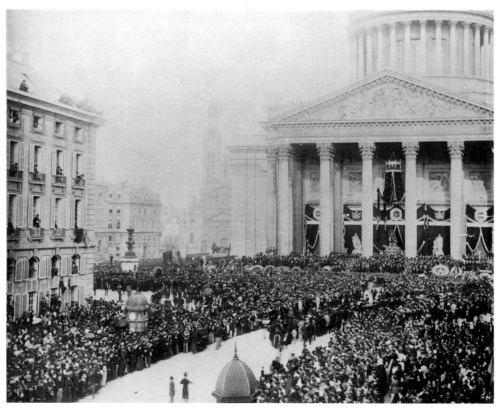

Figure 31

France, 1824–1898

The Childhood of Sainte-Geneviève

1877
Oil on canvas
181⅞ × 87 in. (462 × 221 cm)
Paris, Panthéon
Photo: © CNMHS
(Photo by Caroline Rose)

Figure 32

France, 1833–1922

The Martyrdom of Saint Denis

c. 1874
Oil on canvas
Dimensions unavailable
Paris, Panthéon
Photo: © CNMHS
(Photo by Patrick Cadet)

Figure 33

Hugo's funeral cortège at the Pantheon

1885
Photograph
Photo: © Photo Bulloz

Rodin's Monument to Victor Hugo for the Pantheon

With the liberal government shaky but still in power, France celebrated the centenary of the Great Revolution and inaugurated a vast Universal Exposition, which was created on the Champ-de-Mars and for which the Eiffel Tower was designed and built. In this climate of revolutionary fervor, the government initiated a program of sculpture that would fill the Pantheon's interior with monuments complementing the murals of 1874 and giving witness to the building's secular and Revolutionary history. Announced in February 1889, the sculptural program was intended to celebrate "*la France laïque*" (secular France) as the legitimate successor to "*la France chrétienne*" (Christian France).[22]

At the east end of the building a monument to the Revolution would stand near the spot where the Christian altar had been. Against each of the pillars supporting the building's central dome would be relief sculptures depicting the history of pre-Revolutionary France. And positioned in various spots in the building would be some eighty single-figure sculptures representing the country's great men plus five funerary monuments to commemorate individual heroes and philosophers associated with the revolutionary ideal: René Descartes, Voltaire, Jean-Jacques Rousseau, Mirabeau, and Victor Hugo. The last two, the monuments to Mirabeau and Hugo, were intended to balance and complement each other across the building's transepts, Mirabeau's sculpture standing to the south, Hugo's to the north. The pairing of these monuments was highly significant, since it had been Mirabeau's death that had occasioned the first creation of the Pantheon (1791) and Hugo's death that had brought about the last (1885).

The man who outlined the subjects of the Pantheon sculptures was Lockroy, Hugo's spokesman in the hours before the poet's death and now serving as minister of fine arts. Well aware of the vicissitudes of French politics – during these years when the changes in cabinet were so frequent that the period has been dubbed "the waltz of the ministries"[23] – Lockroy set up a subcommittee that would handle the Pantheon project.[24] In this way he hoped to ensure that the program would be realized despite the constant changes that so marked the political situation in those times. As Charles Bigot commented approvingly in the newspaper *Le Siècle:* "A new minister brings new ideas, wishes to undertake new works. Scarcely has he gotten down to the task, scarcely has he begun, when already he is out. The project he has undertaken is abandoned in favor of another one that will hardly be any better followed up."[25] Lockroy's caution was well placed: two days after

the approval of the Pantheon program and the subcommittee that would administer it, the cabinet fell, and he was forced to resign. Now the implementation of the project was left to Gustave Larroumet, whom Lockroy had appointed as director of fine arts in 1888. Previously a professor of literature at the Sorbonne, Larroumet was also an admirer of Rodin.[26]

In March 1889 the Subcommittee for Works of Art convened for the first time and began to consider the Pantheon project. By then the subcommittee had been expanded so that it comprised a high-powered cadre of the art-world establishment. In addition to Larroumet, who presided over the subcommittee in his capacity as director of fine arts, there were four former directors of fine arts, one of whom was now in charge of all of the museums of France and another of whom had been for many years the head of the École des beaux-arts. There was Chennevières, who had designed and implemented the earlier, religious program for the Pantheon; there was the director of civil buildings and national palaces; a curator at the Louvre; and three men who were established art critics and now worked for the ministry in the capacity of inspectors of fine arts, government agents who oversaw the projects commissioned for the nation.[27]

Representing the artists' community were the painter Bonnat, whose *Martyrdom of Saint Denis* now hung at the entrance to the building; the medal-engraver Jules-Clément Chaplain (1839–1909); and three architects, including Charles Garnier, who had designed the Paris Opéra. Perhaps of most importance to the history of Rodin's monument were the sculptors who served on the subcommittee: Jules Dalou (1838–1902), who was a friend of Rodin and an ambitious artist who had been the recipient of numerous public commissions in the 1880s; and Henri Chapu (1833–1891), who had won the prestigious Prix de Rome in 1855 and specialized in funerary monuments. Finally there was Eugène Guillaume (1822–1905), "the impeccable academician," who had had an illustrious career as a sculptor and had gone on to assume some of the art world's most important administrative posts.[28]

The subcommittee met nine times between March and mid-June 1889, and the minutes from these meetings, now in the Archives nationales, show that the sessions were essentially calm and routine.[29] After convening in the Pantheon to familiarize themselves with the site, the subcommittee met in the ministry's offices in the Palais-Royal and considered each part of the proposal that Lockroy had drawn up. Over the course of their meetings they approved the subjects of the main sculptures as well as the format and

location of each. The only source of friction at this time in the project's history came, ironically, when Larroumet repeatedly asked the subcommittee for suggestions and received nothing more than their placid acceptance of the ideas he had advanced.

At its eighth meeting the subcommittee selected the pool of sculptors from which the Pantheon artists would be chosen. Self-interest ran high, and the sculptors receiving the highest numbers of votes were – in order – Dalou, Guillaume, and Chapu, all of whom were subcommittee members. They were followed by Alexandre Falguière (1831–1900), Antonin Mercié, Auguste Rodin, and about a dozen artists who are lesser known today. At the close of the session Dalou requested that the list be presented in alphabetical order, an arrangement that would conceal the fact that, first and foremost, the subcommittee had voted for its own members. Yet, because of the way the voting had turned out, Dalou, Guillaume, and Chapu had every reason to conclude that when the commissions were awarded, they would be the first recipients.

In a sense Dalou was a natural candidate, perhaps *the* natural candidate, for the Pantheon's monument to Victor Hugo. In the early years he and Rodin had studied at the École impériale spéciale de dessin, the government's training school for commercial art, but, unlike Rodin, Dalou had gone on to matriculate at the École des beaux-arts. A participant in the Commune, Dalou shared Hugo's radical politics and shared the experience of having been exiled from France for his actions against the government. Throughout the conservative 1870s, when Communards were prosecuted by the government, Dalou had lived in England, returning only in 1880, after amnesty had been declared. In the following years he was introduced to Hugo by Rodin, who regarded Dalou as "my first friend," and, when the poet died, it was Dalou, rather than Rodin, who was asked to execute the death mask (figure 34), much to Rodin's consternation.[30]

At the Salon of 1886 Dalou exhibited two sculptures on the subject of Victor Hugo, with which he staked his claim for a monument to the poet. The first was an ambitious painted-plaster sketch, which depicted the body of Hugo beneath a large triumphal arch, capped by allegorical figures and surrounded by characters taken from his works (figure 35).[31] Entitled *Proposal for a Tomb Monument for Victor Hugo to be Erected in the Pantheon* (1885), the work left no one in doubt about the object of Dalou's ambition. The second work, *Memory of 22 May 1885: Victor Hugo on His Deathbed* (1885), was a detail excerpted from lower portion of the first, which

 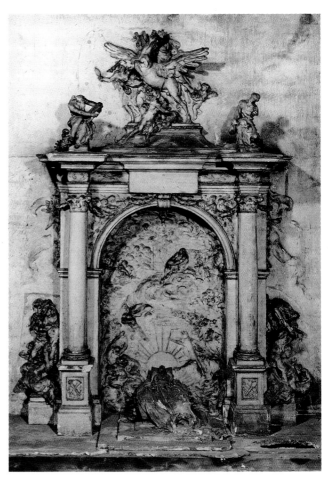

reminded the public that Dalou had witnessed the deathbed scene and could carry into the execution of the monument a real and personal memory. Thus, as an established public sculptor who had first-hand knowledge of Hugo's death and who had announced his candidacy for the monument, Dalou could well have believed that the Pantheon commission was virtually assured.

The subcommittee concluded the first phase of its work in June 1889, when they discussed the monuments to Hugo and Mirabeau, which had been designated to inaugurate the Pantheon program. They agreed that the sculptures should be fairly low to the ground ("*assez bas*"), so that they would not obscure the works at the end of each transept, and they agreed as well that the monuments might "depart from the banal idea of the statue with a pedestal." Larroumet then suggested the general format for these sculptures: "M. le Président [Larroumet] proposed seated figures giving to the dead whom we wish to honor the calm and tranquillity that befits them,

all the while permitting a variety of poses. One could accompany them [Hugo and Mirabeau] with allegorical figures, for example, Eloquence crowning Mirabeau and Poetry glorifying Victor Hugo."[32] The meeting closed with the subcommittee's acceptance of the idea that the two monuments should not be very high ("*peu élevé*") and should show Hugo and Mirabeau attended by allegorical figures.

Though the preliminary meetings had gone smoothly, nothing else about the project would.

By September 1889 Larroumet had summarized the results of the subcommittee's meetings in a report that he sent to the minister of fine arts.[33] At the end of the report he announced that sculptors had been chosen for the monuments that would begin the program, Auguste Rodin for the monument to Hugo and Jean-Antonin Injalbert (1845–1933) for the monument to Mirabeau, and that 75,000 francs had been allotted for each of the projects. Important to Larroumet in making the choice was that the two men were "entirely opposite" in background, training, and style, for he saw it as a duty of the state to remain above the rivalries of artists, neither stooping to engage their quarrels nor responding to anything but artistic talent.[34] The report went on to note that the artists were already at work on their monuments and that their *maquettes,* their design models, were expected momentarily.[35]

By 1889 Rodin's work had reached a larger public, and his reputation soared. Having continued to exhibit at the Salons of the 1880s, he had six sculptures on view at the Universal Exposition of 1889 and thirty-six works in a joint exhibition with Claude Monet (1840–1926) at the Galerie Georges Petit.[36] Though to some degree his sculpture was still resisted by the conservative establishment, he was awarded the Legion of Honor in 1888, and he was appointed as a member of the jury that chose sculpture for the Universal Exposition of 1889. In his report Larroumet provided a fairly complete description of the state of Rodin's monument, from which we can infer that the sculpture in 1889 resembled the small bronze that appears as figure 36.[37] For his monument Rodin chose a politically provocative moment: he depicted the poet during the years of his exile, when he lived on the Channel Islands in protest against Napoleon III. In this sculpture the figure of Hugo sits on a roughly sculpted base that is evocative of Guernsey's rocky terrain (see figure 12) and washed by the waters of the Channel. At the poet's feet break the waves that separate the Channel Islands from France and also form the connection and transit to it. Hugo is depicted with his right

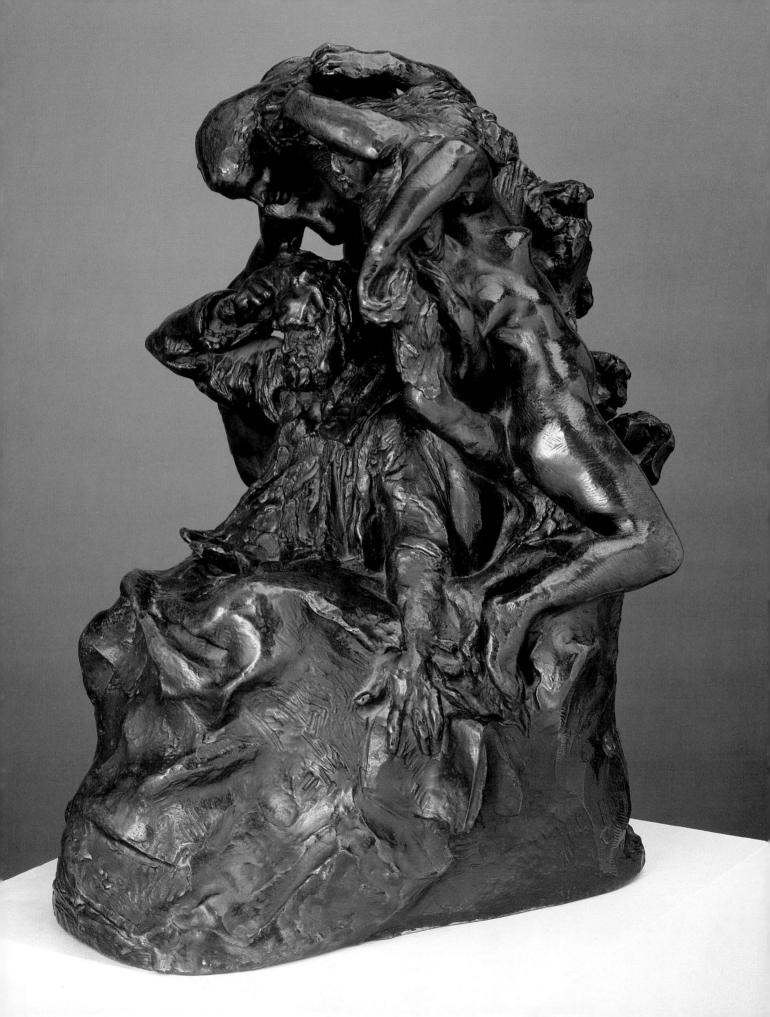

Figure 36 [catalogue no. 6]
AUGUSTE RODIN
France, 1840–1917

*Maquette for The Monument
to Victor Hugo*

c. 1889–90
Bronze
15 × 11³/₈ × 14¹/₈ in.
38.2 × 29 × 36 cm)
Inscribed on back: Rodin
Foundry mark: Griffoul et Lorge
fondeur, Paris. 6 passage, Dombasle
Paris, Musée Rodin
Photo: © Musée Rodin
(Photo by Béatrice Hatala)

Figure 37 [catalogue no. 22]
AUGUSTE RODIN
France, 1840–1917

The Genius of Sculpture

c. 1880–83
Brown ink and wash on brown
transparent paper
10³/₈ × 7¹/₂ in. (26.4 × 19.1 cm)
Inscribed: la genie de la Sculpture/
A. Rodin (in graphite on verso of old
mount)
Mrs. Noah L. Butkin

hand to his head, a conventional gesture of thought that appeared frequently in images of the poet, and Rodin has furrowed the writer's brow and tilted it forward as if to suggest the power and immensity of Hugo's inner life. That the left arm stretches forward joins the active and contemplative lives, in the sense that it projects the thought process outward and anticipates the passage of Hugo's thoughts into the visible words that his readers will receive. Hugo is shown not so much "lost" in thought, as engaged in a highly dynamic process of which the poems, the plays, and the novels will comprise the vigorous result. Significant in Rodin's depiction is the portrayal of Hugo's beard, which situates the poet chronologically in the later years of his life and

distinguishes him from the more conservative – and beardless – writer of his youth.[38] Rodin's monument thus blends the themes of Hugo as creator and Hugo as political activist, commemorating the poet as the spectacular and willful outsider who defied the head of state and proved victorious in the end.

Behind Hugo's head three muses unfold "in the curl of a wave." Embodying the inspiration, the passions, that generated Hugo's works, they suggest as well the germination, the chaos, and the maturation of thought. In Larroumet's description the muses represented "Youth, Maturity, and Old Age," though the precision of the identification sounds more like Larroumet's wishful thinking than Rodin's intent. Through the years that followed, Rodin would change the designation of the muses easily, draining out one meaning and pouring in the next, which suggests that the figures existed as generalized ciphers – signs of Hugo's inner life – and attempts to reify the multiform aspects of the creative drive. Inspiration visualized and the varieties of inner, creative experience were themes that ran through many of Rodin's works, including *The Gates of Hell* (figure 17; 1880–c. 1900), *The Genius of Sculpture* (figure 37; c. 1880–82), and the monuments to Hugo and Balzac.

The Trial and Its Outcome

By March 1890 the maquettes were completed, and the subcommittee visited the studios of Rodin and Injalbert. The minutes from these visits are so noncommital that one senses trouble in the air: the *procès-verbal* (minutes) describes the monuments briefly and notes that the artists will consult with the architect assigned to the Pantheon to discuss the dimensions the figures should take. There is no evidence of enthusiasm about Rodin's project, no hint of a response of any kind.

A letter from Rodin to Larroumet, written on March 24, 1890, provides a description of the project at this phase and indicates that it was the sculptor's understanding that the subcommittee had given approval for his sketch:

As you have done me the honor of asking me for it, I am sending you a note on the sketch [*esquisse*] for the monument that you have commissioned from me, and that the committee of Fine Arts [*sic*] has accepted.

Victor Hugo is seated on the rocks of Guernsey, lashed by waves, three muses inspire him, the one in the middle, most vehement in arms and visage is Avenging Justice, the muse of *Les Châtiments*[;] the one on the left the muse of *Les Orientales*[;] the one on the right is the most ideal. The whole rests on a base that I assume fairly low [*que je suppose assez bas*].[39]

Figure 38
AUGUSTE RODIN
France, 1840–1917

The Monument to Victor Hugo (Variant of Initial Project)
1890
Terra-cotta
Height: 28⅛ in. (71.9 cm)
Vienna, Österreichische Galerie Belvedere

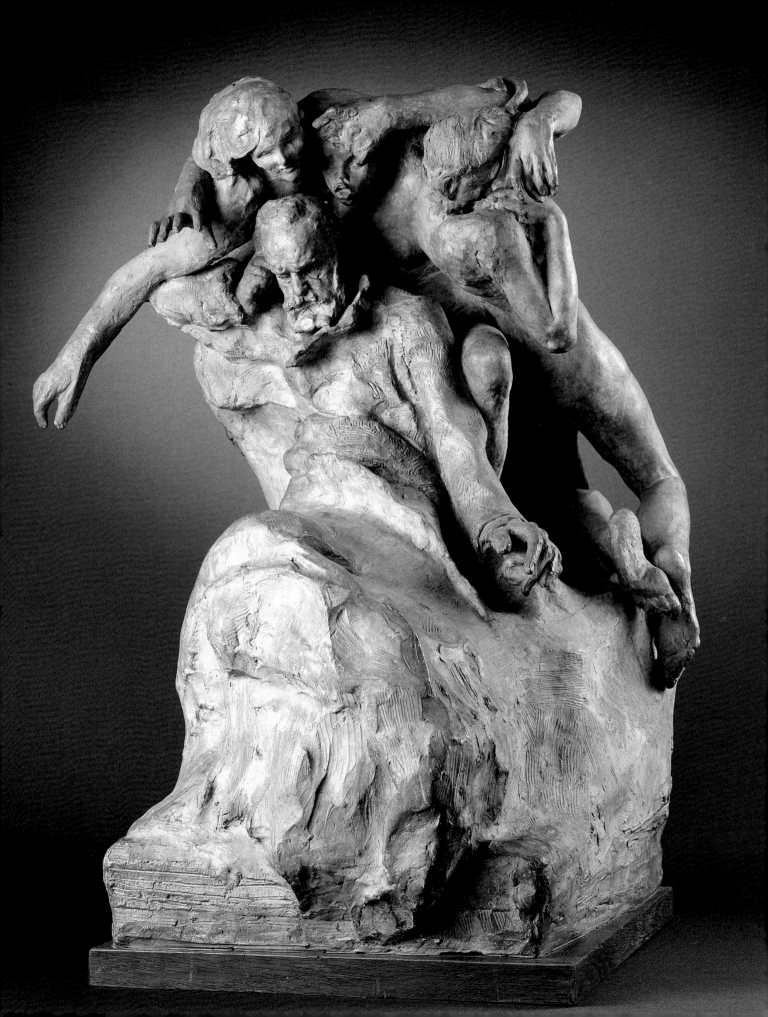

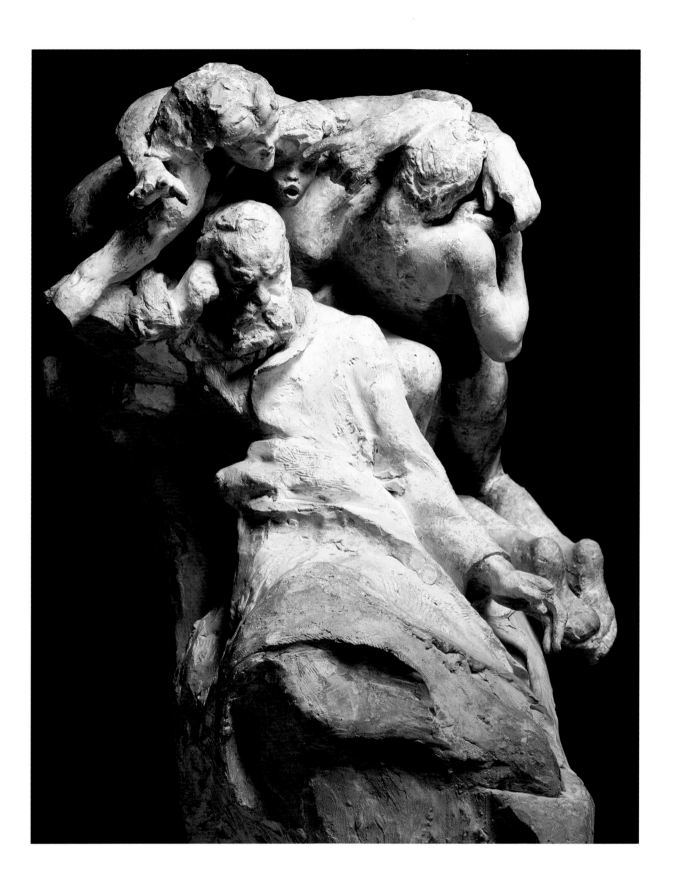

Rodin's letter to the government suggests that the design of the monument had changed very little since Larroumet's description of it in the fall of 1889 and that the sculpture in figure 39 represents a conversion of Rodin's initial idea into the plaster medium required by the Subcommittee for Works of Art (there is also a terra-cotta version, figure 38). Here again the figure of Hugo is backed by three muses, of which the central one is "the most vehement" and is associated with the "Avenging Justice," the political invective, of Hugo's *Châtiments*. Noteworthy in Rodin's characterization is the fluidity with which the muses have changed their significance, the muse on the left signifying now *Les Orientales*, the collection of verse that Hugo published in 1829. Though this figure thus represents a work of Hugo's youth, just as the muse of *Les Châtiments* represents the poems of Hugo's maturity, the third muse is described as being only "the most ideal."

It is important to notice that Rodin's depiction of Hugo – seated on Guernsey and immersed in his thoughts – differed essentially from Injalbert's Mirabeau (figure 40). In Injalbert's far more vertical monument, the orator is shown standing in the midst of one of his most famous political speeches, which was given in the days that immediately preceded his death. His words are inspired by an upward-surging figure of Eloquence, and he is surrounded by allegorical depictions of Liberty, History, and France in 1789.[40] Precise and direct in its symbolism, Injalbert's *Monument to Mirabeau* sets the central figure well above eye-level and offers a grand and glorious tribute to the revolutionary history of France.

The subcommittee's disapproval of Rodin's monument surfaced in the months that followed the visit to his studio. At the end of March they evaluated the projects they had seen, those of Rodin and Injalbert, and the minutes opened with an ominous remark by one of the subcommittee members: "M. Yriarte regrets that before giving the artists their commissions, one did not give attention to the overall proportions of the monuments."[41] Other subcommittee members agreed, the problem being the dissimilar formats of the two monuments. However, when asked by Larroumet if they could accept the artists' ideas as presented in their maquettes, the subcommittee said yes, as long as Injalbert would tighten up his monument and Rodin enlarge his. However, the subcommittee did not let the matter rest there.

At their instigation, Rodin and Injalbert were forced to cooperate in a rather controlling and demeaning attempt to simulate the effect of the monuments in the Pantheon's space. Bizarre though the idea sounds, the

subcommittee decided that the administration would hire a firm of decorative painters, who would reproduce each monument on canvas, on the basis of photographs and the artists' maquettes. The result would be something along the lines of a piece of theatrical scenery: a stretched and painted canvas, done to the anticipated size of each monument and intended to show how it would "really" look.[42]

By summer 1890 the painted simulations were in place. In the case of Rodin's monument, the mock-up seems to have turned out alarmingly small – it was, in fact, half the size of Injalbert's – and the decision was made to increase the height of the painted facsimile by raising it up on a base of artificial rocks ("*des rocs factices*").[43] On July 10 about a dozen members of the subcommittee met in the Pantheon, including Chapu and Dalou, neither of whom had yet received commissions for the program, and Garnier, who held it as an inviolate article of faith that good sculpture should derive its design from the architecture that surrounded it.[44]

This time the subcommittee was unequivocal in its judgments: they thought the proportions of Injalbert's monument were good, and they accepted his sketch; they thought that Rodin's monument lacked clarity and – to a man – they rejected his design. As was noted in the minutes, "The Subcommittee *unanimously* pronounced itself against the project presented by M. Rodin, which lacks clarity and of which the silhouette is confused. Thus, the artist will be asked to present another sketch, concerning himself with the architectural milieu in which the monument to Victor Hugo will be placed."[45] Adding to the insult, the subcommittee required that Rodin come to the Pantheon, where, in front of the model, the deficiencies of his monument would be enumerated.

Within days newspaper reporters sprang to Rodin's defense. In *La Justice* on July 19 Roger Berment wrote that, if the committee had wanted absolute homogeneity, they should have given the entire program to Rodin.[46] In *Le Siècle* René Lavoix reprinted extracts from three other newspapers, all of which noted that Rodin had designed his monument to sit on the spectators' level, so that it could be seen "horizontally and not from below upward." The article went on to comment that "the subjects that compose the monument were made to be looked at in this way, and the work is completely disfigured, completely transformed when it is seen from below."[47] Lavoix interviewed Larroumet, who stated that during the Pantheon trials Rodin's monument appeared "to be crushed by the columns that surrounded it, at the same time that the different subjects grouped together seem[ed] to lack

space and air." Though the sculpture had "qualities that were real and incontestable," Larroumet had concluded that it simply did not work in the Pantheon's space.[48]

On July 20 *Le Journal des débats* reprinted Lavoix's article and added an interview with Rodin. Here the sculptor said that he had just spoken with Larroumet, who advised that the new project should be "larger ... more monumental." Rodin seems to have accepted the defeat philosophically, replying that independent artists always had trouble with official groups, Jean-Baptiste Carpeaux (1827–1875), among others, having experienced similar vexations. This last remark was a reference to the architect Garnier, who had caused for Carpeaux's sculpture *The Dance* (1865–69) some of the same difficulties he now contributed to creating for Rodin's *Monument to Victor Hugo*.[49]

In *Le Paris* on July 21 Arsène Alexandre also attacked the idea that Rodin's monument had been raised "to a height for which it had not been intended," and he criticized the subcommittee as "four or five pencil-pushers and two or three bigwigs who, now, direct the inspiration of an artist of this stature!" Alexandre's actual phrasing is much more colorful than a translation can possibly convey: where English usage would say "pencil-pushers," Alexandre called the men *ronds-de-cuir* – literally, the round, leather seat-cushions on which a bureaucrat's bottom would rest – and where we would say "bigwigs," Alexandre used the term *pontifes*, a word that carries with it the negative connotations of unwanted ecclesiastical authority that speaks from a position of infallibility. In Alexandre's assessment, that Rodin had created a moving, eloquent work, only to be forced to conform to Injalbert's *fla-fla décoratif*, was *le sublime administratif*.[50]

On July 22 in *La Justice* Gustave Geffroy reprinted parts of Alexandre's article and penned an eloquent defense of Rodin's sculpture. It was impossible to comprehend, he wrote, how the subcommittee could have accepted Injalbert's project but rejected Rodin's "magnificent monument." In Geffroy's extremely sensitive reading of the monument, the figure of Hugo stares at the waves that lap his small island "and that will leave, with the next tide, to break against the coast of France." As to the muses:

Never has the inspiration that whispers and cries been expressed in a more thrilling manner, at once grandiose and intimate. There is a haste and a fever in the gathering of these three bodies, which are of an infinite youth and suppleness. The languid and tense faces approach one another, the

arms are fastened around the bodies like vines, the hair and breasts lightly brush against the poet. An atmosphere of seduction envelops him, an obsession of ideas and of song holds him in its grip.[51]

At the end of his article Geffroy reprinted Alexandre's remarks about *ronds-de-cuir* and *pontifes* and concluded that, in his opinion, too, Rodin had given in too easily to a subcommittee that was "sometimes evil-minded, and useless always."[52]

Finally on August 10 Octave Mirbeau attacked the subcommittee in *Le Figaro*, condemning "the omnipotence of their collective imbecility." He compared Rodin's monument to Michelangelo's work in the Sistine Chapel: Julius II had been more tractable than the subcommittee, but after all he had only been a pope. In Mirbeau's eyes it was "a real scandal" that Rodin's work should have been judged by men who were clearly his inferiors:

Isn't it a real scandal and a revolting anomaly to place an artist under the surveillance and dependence of men who are notoriously inferior to him, to imprison his intellectual activity, his creative genius in the opinion of men who form part of a committee because some are art critics, other inspectors of fine arts or directors of museums, that is to say, the holders of functions that are chimerical and indefinable, uniquely created for those alone who cannot make anything in life, not a book, not a piece of vaudeville, not a poem, not a painting, not a cantata, not a house, not a newspaper article, not a pair of boots![53]

In the end Larroumet refused to reverse the rejection of Rodin's maquette, even though the awkwardly elevated paint-and-canvas simulation had disastrously altered the character of Rodin's design.[54] Trapped between the Scylla and Charybdis of his own desires – appeasing the subcommittee on the one side and retaining Rodin's *Monument to Victor Hugo* on the other – Larroumet resolved the situation solomonically, by removing this version of Rodin's monument from the Pantheon's program and designating it for either a museum or an outdoor site.[55] Thus, despite the rejection of his maquette, Rodin gained a second commission from the state for a monument in Hugo's honor, and through the 1890s he would continue to revise his project for the Pantheon, as well as completing the outdoor sculpture that Larroumet accepted on the government's behalf. It was following the trials in 1890 that Rodin arranged to have executed in terra-cotta the version of the monument that the subcommittee had turned down (figure 38).[56]

Figure 41
AUGUSTE RODIN
France, 1840–1917
c. 1895
Plaster
Height: 44⅛ in. (112.2 cm)
Paris, Musée Rodin
Photo: © CNMHS

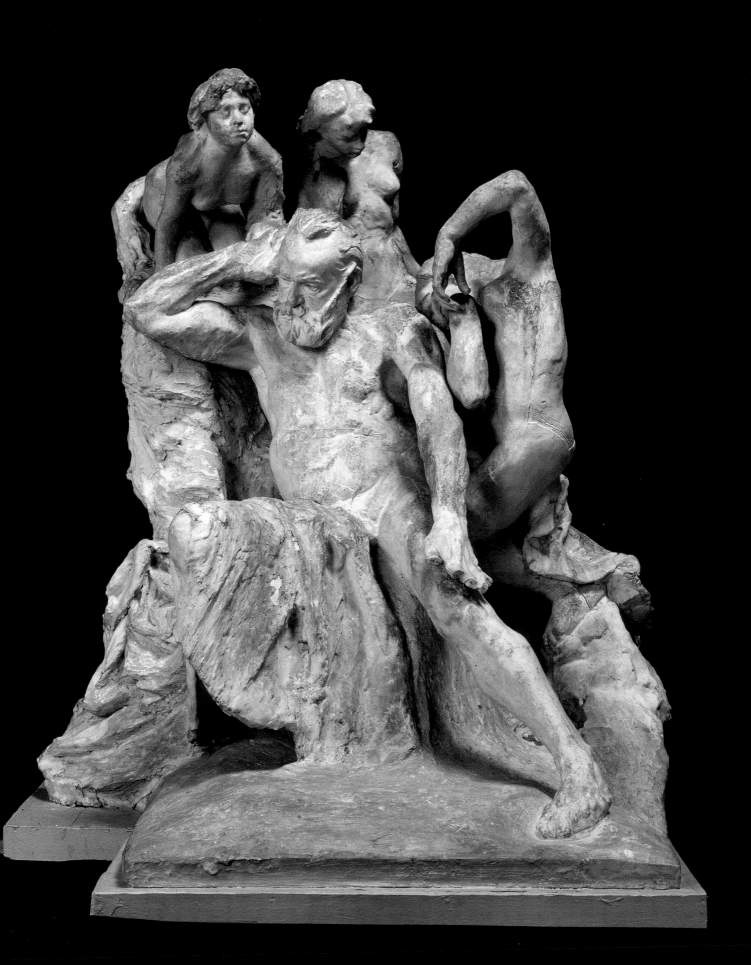

In hindsight we can discern that many complications affected the decision to reject Rodin's work. The first was the composition of the subcommittee, in that it included so many high-powered members of the establishment to which Rodin was an outsider, as well as two sculptors, Dalou and Chapu, whose ambition and self-interest may well have prevented them from making a fair and impartial judgment. In addition, a number of the men clearly disliked innovative public sculpture, Garnier and Yriarte among them, while there were others with whom Rodin had had previous, and unpleasant, dealings. There was Chennevières, for example, who loathed any sort of experimental, modernist art and who, as the head of the fine arts from 1873 to 1878, had refused to dispel the accusations that Rodin's *Age of Bronze* had been cast directly from the model's body. Pathologically royalist and Catholic in his politics, Chennevières had initiated the program of religious paintings for the church of Sainte-Geneviève and loathed the building's present secular status. Then there were Albert Kaempfen and Georges Lafenestre, the one the director of the nation's museums, the other curator of sculpture at the Louvre, who had been among the signers of a report on *The Age of Bronze* which was highly critical of Rodin's abilities. It can well be imagined that the remaining members of the Subcommittee for Works of Art allowed themselves to be swayed by the negativity, the power politics, swirling in the air around them.

Second, it is clear that the expectations concerning Rodin's monument to Hugo changed between the time of the subcommittee's first discussions (spring 1889) and the day when the paint-and-canvas mock-ups were viewed (summer 1890). As the documents consistently suggest, the commission had been given to Rodin with the idea that he would produce a fairly low monument, in which Victor Hugo was shown in a seated position. Except for Larroumet, no one on the subcommittee seems to have been troubled by the fact that when they rejected Rodin's monument, they rejected a work the format of which they had discussed – and approved – in advance. Faced with the disparity between the monuments by Injalbert and Rodin, the subcommittee changed its mind about the format of Rodin's sculpture, saying that the seated figure of Hugo seemed crushed, overwhelmed by the architecture around it. In truth, given the vast scale of the Pantheon's architecture, virtually any sculpture, even Injalbert's, would surely have been diminished when it stood alone among the transept's majestic columns and pilasters. Worse yet was the botched attempt to increase the height of Rodin's monument, with the addition of those jury-rigged, make-believe

rocks. Could any sculpture have overcome the effect of that makeshift base, much less a dense, compact, and subtle sculpture that was designed to sit in the viewer's space and to engage the viewer head on?

Finally, and to my mind most importantly, there was the conflict, both aesthetic and ideological, between the individualism of Rodin's sculpture, an individualism that was a significant part of his reputation, and the shared, communal conventions that governed public sculpture and that were, in fact, its *raison d'être*. From this point of view Injalbert's *fla-fla décoratif* met with no resistance from the Subcommittee for Works of Art, not because it was inventive or original, as Rodin's sculpture was, but because the *Monument to Mirabeau* adhered to the rules and, thus, gave actual, physical form to such ideas as consensus and solidarity, and to such attitudes as submission, conformity, obedience, and cooperation.

As I am sure many viewers of this exhibition will realize, looking at a sculpture involves a much more complex process than the word *looking* conveys. Confronted with a work of art, we enter into it empathetically, in a way that engages not only our eyes but also our minds and our emotions.[57] In a psychological sense we merge with a sculpture when we look at it; we lose consciousness of the gallery or building around us, and we possess the work, in the sense that we absorb it and take it into ourselves. When the sculpture we are viewing is a civic work, commissioned by a government and financed with public funds, the personal and the political converge, and our absorption of the sculpture can trigger issues about our expectations for that government and about our own place in its sociopolitical hierarchy. Thus, an aesthetic surprise comes as an unpleasant shock if we desire that our government remain stable and predictable and if we fear an alteration to the *status quo*. And when the subject and the location of the work come freighted with the weight of revolution, as the Pantheon's Hugo monument did, the viewer's potential discomfort can increase exponentially if the themes of civil war and political activism are not offset and stabilized by the soothing language of sculptural convention.

Thus, the very originality of Rodin's *Monument to Victor Hugo* was received as threatening, troubling, and transgressive, at a time when conformity, allegiance, and cooperation were deeply desired and when consensus and solidarity were values absent in the country at large. Arsène Alexandre described his reaction to Rodin's sculpture in terms of the "surprise" and "shock" that his works always brought: "We love the art of Rodin, because each of his works carries for us always a profound surprise,

Figure 42

AUGUSTE RODIN

France, 1840–1917

The Burghers of Calais

1884–88, Musée Rodin cast I/II, 1985
Bronze
82¹⁄₂ × 94 × 75 in. (209.6 × 238.7 × 190.5 cm)
Foundry: Coubertin
The Metropolitan Museum of Art, New York,
Gift of Iris and B. Gerald Cantor

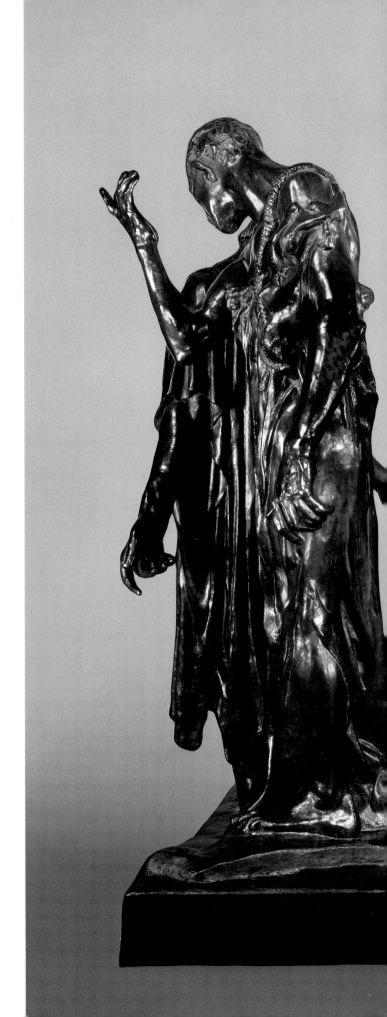

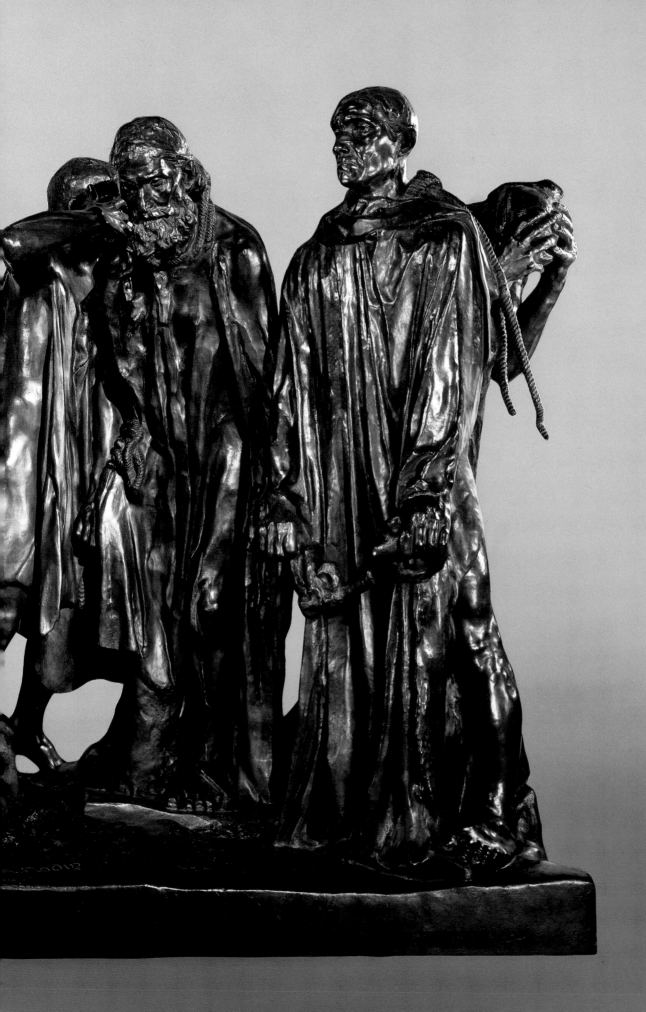

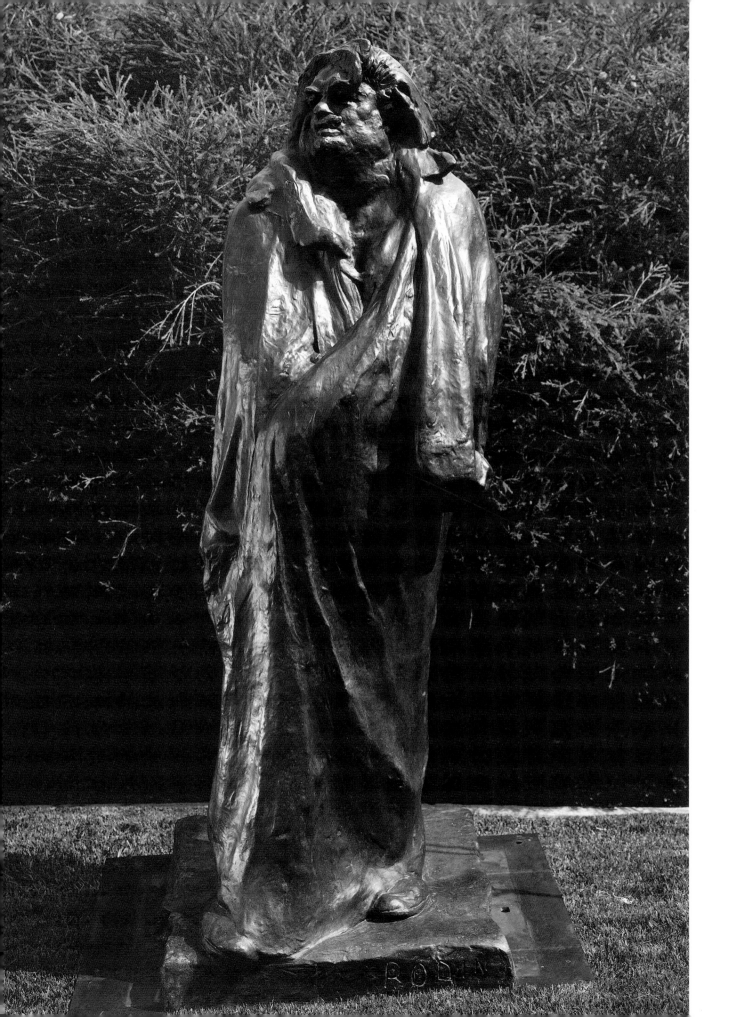

Figure 43
AUGUSTE RODIN
France, 1840–1917

The Monument to Balzac

c. 1897, Musée Rodin cast 9/12, 1967
Bronze
117 × 47¼ × 47¼ in.
(297.2 × 120 × 120 cm)
Foundry: Susse
Los Angeles County Museum of Art,
Gift of B. Gerald Cantor Art
Foundation

that shock of emotion that reminds us again of why we look at works of art Great artists ... see more and more quickly than the others, and ... following their example, we are taught to see more things than we saw before. It is for this reason that we have to consider the art of Rodin as an emancipator."[58] However, surprise and shock and emancipation were among the last reactions desired from public art in *fin-de-siècle* France, and Rodin's individualistic approach to monumental sculpture – like Hugo, he was one man taking action against a dominant ideology – in and of itself could be seen to attack the *status quo.*

The Later History of Rodin's Monument to Victor Hugo

In the mid-1890s the suspicions about Rodin and his monuments deepened. When a resurgence of Catholicism problematized Hugo's anticlericalism and when the Dreyfus Affair cleaved the nation in two, the originality and individualism of Rodin's approach became virtually impossible for the government and for much of the public to internalize and support. That so many of Rodin's supporters in the press had clearly identified themselves as *Dreyfusards* (supporters of Dreyfus in his battle to establish his innocence) gave Rodin's reputation for nonconformity a dangerous and liberal political edge. Regardless of his actual politics, which were indeed quite conservative,[59] his unorthodox background and his refusal to play by the rules of "good" sculpture marked him as an outsider, and "outsider art" was troubling in the xenophobic climate of the 1890s.

With innovation and originality as signifiers of an unruly, transgressive spirit, the feeling spread that Rodin's projects needed to be brought under control. During this period he continued to work on the monument to Victor Hugo, though he was pressured from all sides – bombarded is not inappropriate here – with demands that he finish his projects. The city of Calais wrote him constantly, pleading that he complete his statue of *The Burghers,* which had been commissioned in 1884 (figure 42). The Société des gens de lettres repeatedly tried to force him to finish and part with the monument to Honoré de Balzac, which they had negotiated in 1891 (figure 43). And the ministry of fine arts pressed him to speed up work on both of his monuments to Victor Hugo.[60]

Not surprisingly, when Edmond de Goncourt encountered Rodin in the summer of 1895, the writer noted in his journal how stressed and depressed Rodin seemed: "On the train, Rodin, whom I find truly changed and very melancholy in his state of collapse, in the fatigue he suffers from work at the

moment, complains almost painfully of the vexations that in the *métier* of a sculptor or painter are inflicted on artists by committees of art." Instead of facilitating an artist's work, these committees impeded it with their constant requests, with the steps and procedures they forced an artist to follow.[61]

Though the initial version of Rodin's monument had been removed from the Pantheon program, that is not to say that the project had been freed entirely from government control. In January 1894 Armand Silvestre, one of the government's inspectors for the arts, was sent to Rodin's studio to check on the monument's progress. From the report it sounds as if Rodin had not changed his ideas very much, though each of the muses had now come to signify one of Hugo's poetic works: *Les Orientales*, *Les Voix intérieures* (1837), both of which were written early in his career, and *Les Châtiments*, published during his exile in Guernsey. Typical of Rodin's procedure, he was now working the figure of Hugo from a nude model (figure 44), but nothing in the report suggests that a nude Hugo would be Rodin's final intent. In Silvestre's opinion, "Presently the *Victor Hugo* of M. Rodin represents only a sum, very interesting it is true, of studies for which a payment of 5000 F would be sufficiently remunerative."[62]

A year later Silvestre called on Rodin again. Great progress had been made, and this time Silvestre's report was enthusiastic: Rodin "had been well inspired to modify his first idea and it is certainly the well-resolved project ... that he submits to us [figure 45]." In Silvestre's opinion the figure of Hugo possessed "something indefinably Olympian, which recalls the most beautiful conceptions of ancient art," and the gesture of the poet now projected "an incomparable grandeur." As to the muses, Rodin had separated them one from another and brought them forward around the figure of Hugo (figure 41), so that "now they spring, to magnificent effect, above his head, like waves that unfurl." In its present state – and if Rodin would finally agree to stop work – *The Monument to Victor Hugo* was truly "a work with an imposing effect and a great intensity of thought."[63]

However, Rodin did not stop work. Continuing to apply pressure, the government began negotiations for the marble out of which the sculpture would be carved. By August 1895 Rodin had submitted the necessary *saumons*, the rough indications of size that would be used in choosing the block, and in October the marble arrived in his studio.[64] At the Salon of 1897 he exhibited a rough enlargement of the final direction of his thoughts, with the notation "*bras de femme incomplet* [arm of a female figure incomplete]" (figures 46–47).[65] By now he had settled on the idea of depicting Hugo nude,

Figure 44 [catalogue no. 8]

AUGUSTE RODIN

France, 1840–1917

Nude Study for The
Monument to Victor Hugo

c. 1893–94

Plaster

34⅝ × 32 × 30⅜ in.

(88.4 × 81.6 × 77.1 cm)

Inscribed on base: Première épreuve

Paris, Musée Rodin

Photo: © Musée Rodin and Adam
Rzepka/ADAGP

Figure 45

AUGUSTE RODIN

France, 1840–1917

The Monument to Victor Hugo

after 1900

Plaster

72¾ × 122 × 64 in.

(184.4 × 310 × 162.6 cm)

Paris, Musée Rodin

Photo: © Musée Rodin

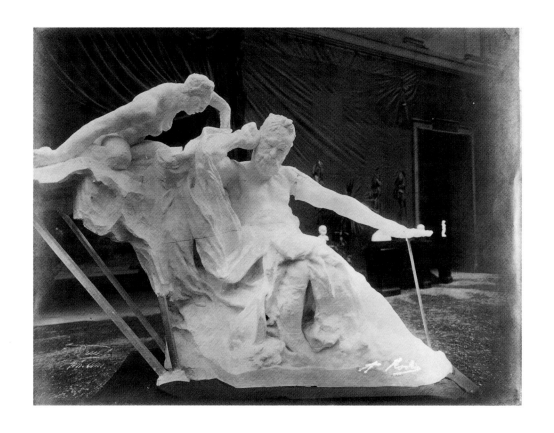

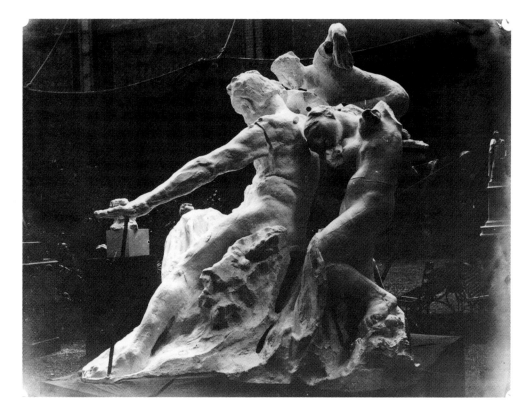

and he had reduced the muses to two: the Tragic Muse raging behind Hugo's head and the Interior Voice standing gently to the side. While a number of critics ignored the sculpture's sketchy and fragmented state – or even appreciated it as more powerfully evocative than a highly finished work – Lafenestre found the work regrettably incomprehensible. As one of the men who rejected Rodin's first project for the Pantheon and as a critic who had no love for Rodin's work, Lafenestre panned the sculpture in the influential *Revue des deux mondes*:

This work, in its present state, is nothing more than a piecemeal, incoherent study [*maquette*], on which it would be premature to pass judgment. The catalogue is willing to forewarn us that, in this colossal sketch [*ébauche*], an arm of a female figure is incomplete; it is an optimistic catalogue. Oh! If there were only an arm incomplete! Another arm, it is true, is long beyond measure; but is that compensation?[66]

It might seem peculiar to a twentieth-century audience that Rodin portrayed Hugo as a nude figure, in the sense that we expect the depiction of a real person, especially someone who is contemporary or nearly contemporary with the artist, to be grounded in the particularities of both likeness and dress. In painted or sculpted portraits clothing serves to situate the figure in a certain time and place and to evoke the idea of the fragility, the time-boundedness, of a particular human life. Generally nudity is reserved for celestial, mythic figures, or, to phrase the idea from the other way around, depicting a figure nude is a way of suggesting that this personage exists outside the inescapable boundaries of time, that he or she is more an abstraction than flesh and blood. Thus, the simple explanation for Rodin's Olympian, nude conception is that the artist conceived of Hugo as a godlike figure, the "French Jupiter" mentioned in the conversations with Henri-Charles-Étienne Dujardin-Beaumetz and someone whose genius removed him from the realm of ordinary human beings. And yet there is a deeper level to the portrayal of Hugo in the nude.

During the time of Hugo's exile, the eighteen years he spent outside France and the period commemorated in Rodin's sculpture, Hugo became in the minds of the French a remote, abstracted presence, a formerly real-world writer who had been transmuted into a timeless, transcendent literary "voice." Having absented himself from the everyday doings of the Second Empire, Hugo existed as a strangely disembodied figure, a projection of the national conscience, and a symbolic spirit who lived, invisibly, through the

words on a page. "An exile is like a dead man," Hugo wrote, and his was "the voice from beyond the grave."[67] Artists of the period saw Hugo as more Olympian than real, and whether they were *hugophobes* (figure 48) or *hugolâtres* (figure 49) – whether they hated Hugo or idolized him – they very naturally depicted him as nude. Thus, Rodin's decision to strip the figure of its clothing and erase from the monument the specifics of time and place seems, paradoxically, more fitting and powerful than the frock-coated portrayal of Hugo had been. In this later version of the monument the nude figure of Hugo becomes a sign for his unreal presence during the exile – or his real absence, if you will – just as nude muses become the metaphorical embodiments of his equally invisible interior life.

After the Salon of 1897 Rodin virtually abandoned work on the Hugo monument. The cause undoubtedly was the rejection of his *Monument to Balzac*, a project that had troubled him all through the decade. In 1898 the Société des gens de lettres refused to accept Rodin's design; they canceled his commission and chose another sculptor for the project.[68] The effect on Rodin was cataclysmic – he had now had two monuments rejected in the space of eight years – and he seems to have lost all interest in large-scale public sculpture. Although he still had the muses to complete and although additional stone had been delivered to his studio, he dropped these figures in the monument's marble version (figures 50–51). As it was inaugurated in 1909, Rodin's *Monument to Victor Hugo* was a commemoration of profound, existential isolation: the poet, the thinker, the creator, listening to nobody, in exile, and alone. This is a conception of Hugo that seems eloquently revealing of Rodin's own situation, his outsider status, at the end of the nineteenth century. However, the muses did not entirely disappear from view, and figures and fragments of *The Tragic Muse* (figures 52–53) and *The Interior Voice*, renamed *Meditation* (figures 54–56), assumed new and independent significance as individual, self-sufficient works.

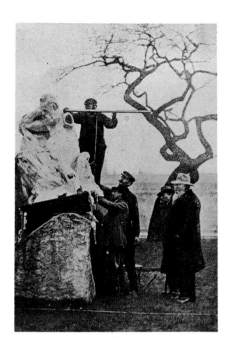

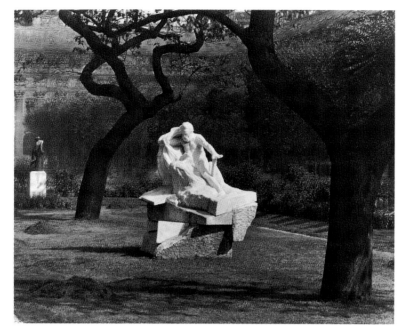

Figure 48

Caricature of Victor Hugo

1896
Photo: © Bibliothèque Nationale de
France

Figure 49

France, 1848–1899

The Exiled Poet

1867
Drawing after a sculpture
Photo: © Bibliothèque Nationale de
France

Figure 50

*Auguste Rodin with a cast of
The Monument to Victor Hugo,
in the gardens of the Palais
Royal, Paris*

Reproduced from *L'Illustration*,
3 April 1909

Figure 51

*Rodin's Monument to Victor
Hugo photographed in the
gardens of the Palais Royal,
Paris*

no date
Paris, Musée Rodin
Photo: © Musée Rodin

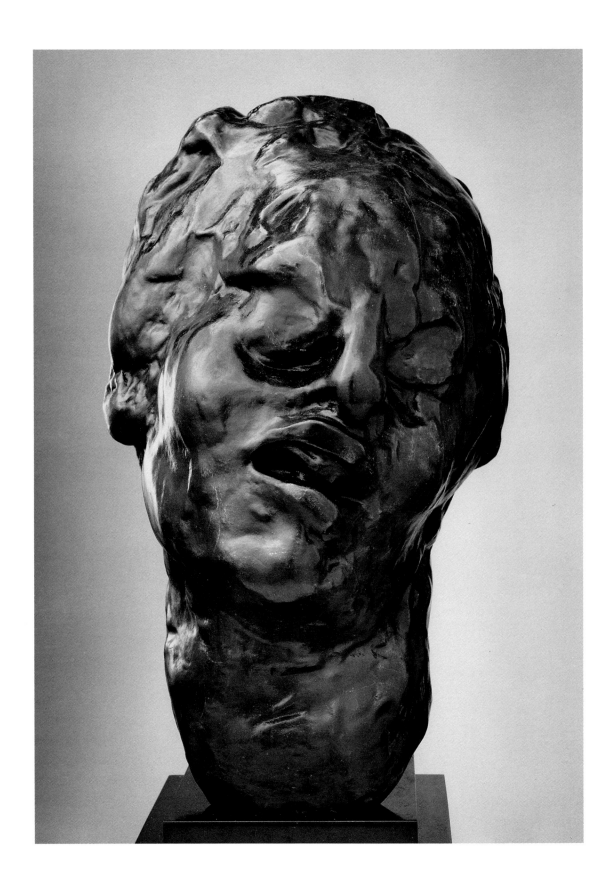

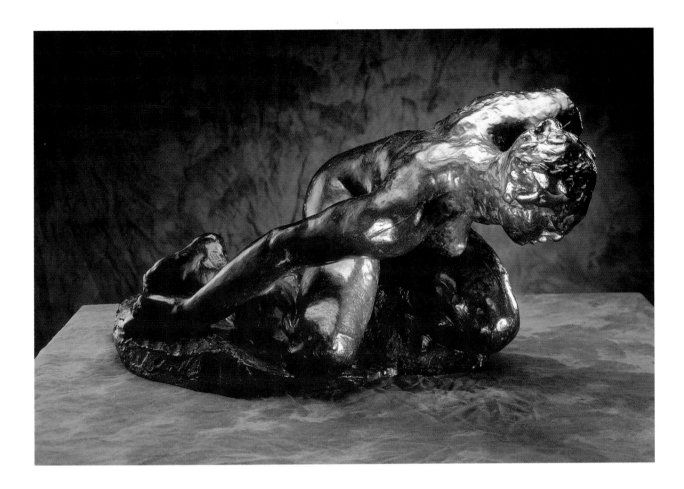

Figure 52 [catalogue no. 15]

AUGUSTE RODIN

France, 1840–1917

Head of the Tragic Muse

1890-96, Musée Rodin cast 5/12, 1979

Bronze

11⅝ × 7¼ × 9⅞ in.

(29.5 × 18.4 × 25.1 cm)

Inscribed on neck, proper left side: A. Rodin N⁰. 5; on
bottom, proper left toward the back: © by musée Rodin 1979

Foundry mark on back at bottom: Georges Rudier Fondeur
Paris

Brooklyn Museum of Art, Gift of the Iris and B. Gerald
Cantor Foundation

Figure 53 [catalogue no. 14]

AUGUSTE RODIN

France, 1840–1917

The Tragic Muse

1890–96, Musée Rodin cast 3/8 in 1986

Bronze

13 × 25½ × 15¼ in. (33 × 64.8 × 38.7 cm)

Inscribed on rock base under proper left foot: A. Rodin;
and on side of base under proper right hand: © BY MUSEE
Rodin 1986

Foundry mark on side of rock base, under proper right foot:
E. GODARD FONDEUR

Iris and B. Gerald Cantor Foundation

(Photo by Steve Oliver)

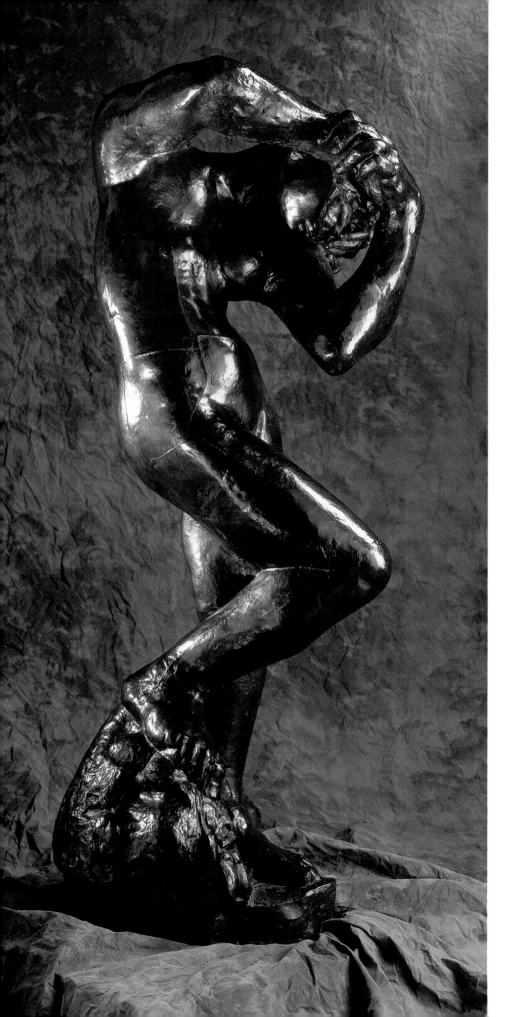

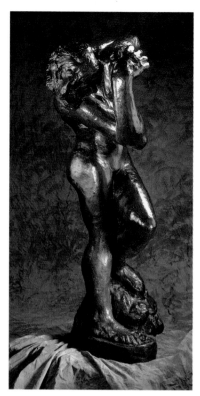

Figures 54–55 [catalogue no. 13]
AUGUSTE RODIN
France, 1840–1917

Meditation (with Arms)

Originally conceived for *The Gates of Hell*, c. 1885–87; separated from definitive *Monument to Victor Hugo* as independent sculpture shortly after 1900; Musée Rodin cast 9, 1980
Bronze
61 × 25 × 25 in.
(159.4 × 63.5 × 63.5 cm)
Inscribed on base, below proper left foot: A. Rodin N⁰ 9; on left side of base: © by musée Rodin 1980
Coubertin foundry mark above inscription to the right: FC with rising sun (in relief)
Iris and B. Gerald Cantor Foundation
(Photos by Steve Oliver)

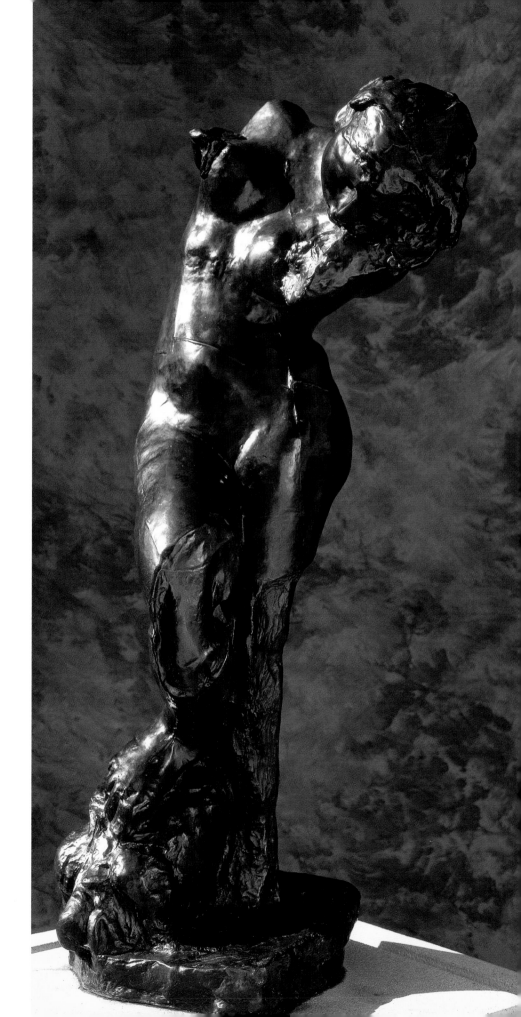

Figure 56 [catalogue no. 12]
AUGUSTE RODIN
France, 1840–1917

Meditation (without Arms)

c. 1884–85, enlarged 1895–96,
Musée Rodin cast 6/8, 1983
Bronze
57¹⁄₂ × 28 × 22¹⁄₈ in.
(146.1 × 71.1 × 56.2 cm)
Inscribed on base to right of figure's
proper left leg: A. Rodin Nᵒ 6/8; also
at bottom back of base: © By musée
Rodin 1983
Coubertin foundry mark to the left of
second inscription: FC with rising sun
(in relief)
Iris and B. Gerald Cantor Collection
(Photo by Steve Oliver)

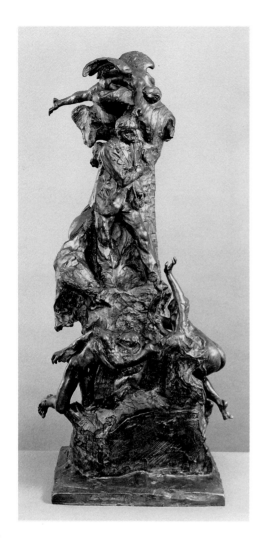

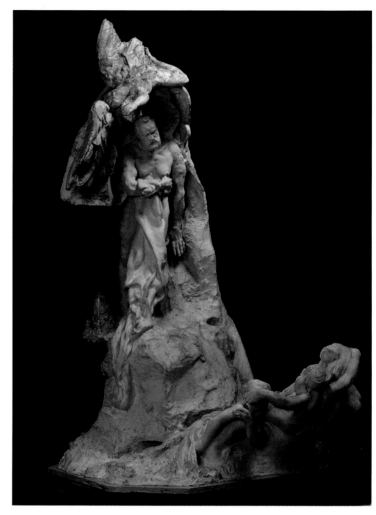

Figure 57 [catalogue no. 7]
AUGUSTE RODIN
France, 1840–1917

The Apotheosis of Victor Hugo

1890–91, cast 1925–26
Bronze
44 × 20¼ × 24 in. (111.8 × 51.4 × 61 cm)
Inscribed on base, proper right: A. Rodin
Foundry mark on base, back proper left:
ALEXIS RUDIER M R/Fondeur. PARIS. N⁰ 1
Bequest of Jules E. Mastbaum;
Rodin Museum, Philadelphia
(Photo by Murray Weiss, 1976)

Figure 58
AUGUSTE RODIN
France, 1840–1917

The Apotheosis of Victor Hugo (Study for The Monument to Victor Hugo)

1891–94
Plaster
86 × 57⅝ × 43⅜ in. (218.4 × 146.3 × 110.2 cm)
Paris, Musée Rodin
Photo: © Musée Rodin
(Photo by Béatrice Hatala)

The Death of the Pantheon Program

Rodin never finished *The Monument to Victor Hugo* for the Pantheon. When his initial conception was rejected in 1890 and removed from the program, he began a second monument for the Pantheon, this one depicting Hugo standing on his rocky island (figure 57) in a pose more nearly complementary to Injalbert's monument to Mirabeau. In 1891 he once again submitted his ideas to the Subcommittee for Works of Art, and they once again demanded the execution of a painted facsimile.[69] This time they did not reject the sculpture outright – did not dare to reject it because of Rodin's popularity with the press – but they requested substantial alterations to the design.[70] When Rodin reworked the project in the ensuing years, he reconceived the figure of Hugo as a colossal, godlike nude (figures 58–59) and set *Iris, Messenger of the Gods,* foot in hand and displaying her sex, eerily flying above the poet's head (figures 59 and 61). Rodin placed three entwined figures, variously called Nereids (sea nymphs) or Sirens, which he adapted from *The Gates of Hell* and from his first version of the monument (see figures 36 and 64), arising from the waves that surround the poet's rock. Now envisioned to measure some twenty-two feet high, the *Apotheosis of Victor Hugo* would have attained the height of a two-story building, the height of Rodin's *Gates of Hell.*[71] Little further work was carried out, and the commission was annulled after Rodin's death in 1917.

Figure 59

AUGUSTE RODIN

France, 1840–1917

The Apotheosis of Victor Hugo
(detail)

1891–94
Plaster
Height: 88⅞ in. (225.6 cm)
Paris, Musée Rodin
Photo: © Musée Rodin

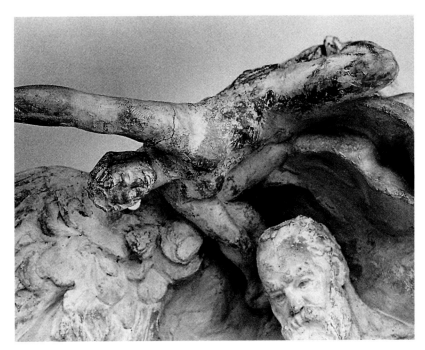

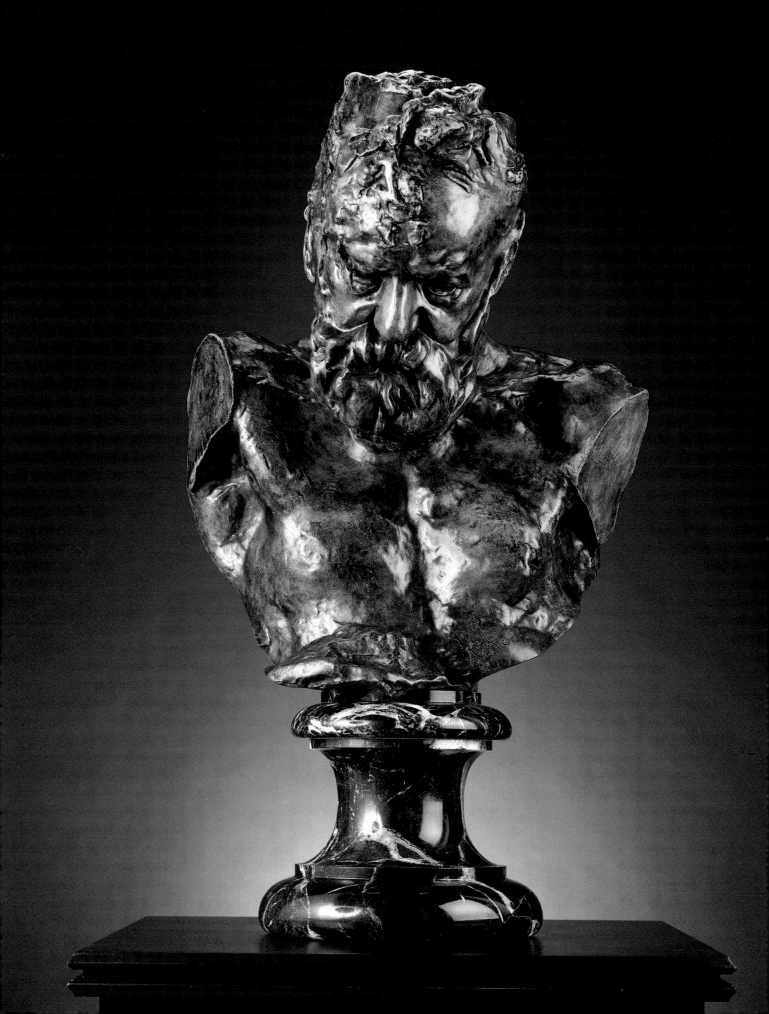

Figure 61 [catalogue no. 17]

AUGUSTE RODIN

France, 1840–1917

Iris, Messenger of the Gods (without Head)

1890–1900, Musée Rodin
cast 9/12, 1966
Bronze
31 × 35 × 14 in.
(78.7 × 88.9 × 35.6 cm) (without base)
Inscribed on sole of proper right foot:
A. Rodin; on base, left: © by musée Rodin.1966
Foundry mark on base, back:
.Georges Rudier./.Fondeur.Paris.
Los Angeles County Museum of Art,
Gift of B. Gerald Cantor Art Foundation

Figure 60 [catalogue no. 10]

AUGUSTE RODIN

France, 1840–1917

Heroic Bust of Victor Hugo

1890–97 or 1901–02, Musée Rodin
cast 5/12, 1967
Bronze
27¾ × 18¾ × 18¾ in.
(70.5 × 47.6 × 47.6 cm)
Inscribed on torso, proper left:
A. Rodin; below this, on support:
© by musée Rodin.1967.
Foundry mark on back of proper right shoulder: .Georges Rudier./.Fondeur. Paris.
Los Angeles County Museum of Art,
Gift of B. Gerald Cantor Art Foundation
(Photo by Steve Oliver)

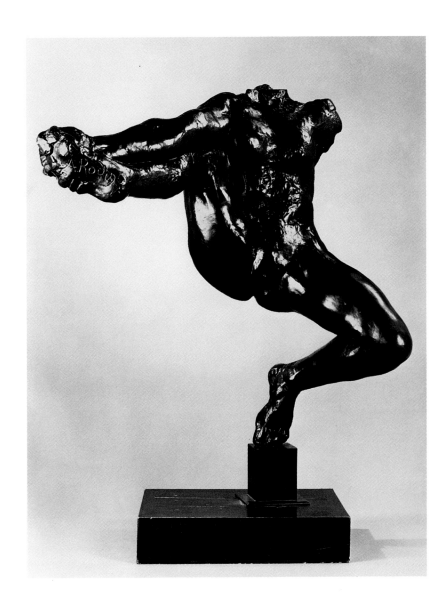

Iris, Messenger of the Gods (see also figures 62–63) is one of the most compelling of Rodin's fragments in its risky imbalance and its forthright depiction of female genitalia. That the figure takes its right foot in hand calls to mind a colloquial French expression, possibly of recent origin: "*se prendre le pied*" is a vernacular way of saying "to have an orgasm." One of several such creations in Rodin's oeuvre (see figure 65), *Iris, Messenger of the Gods* directly connects the erotic, physical libido with the aestheticized creative drive. Fitting in relation to Hugo, whose sexual exploits were prodigious and well known, the motif seems nonetheless an aberrant choice in the context of a civic monument meant to honor one of the Pantheon's great men. Yet

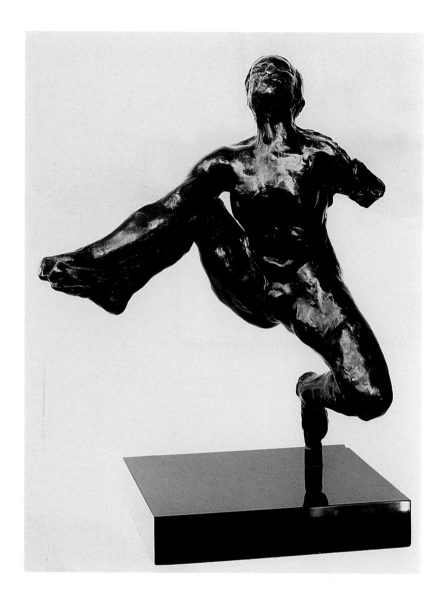

given the colossal scale of *The Apotheosis of Victor Hugo*, the genitals of *Iris* would have been tucked away at the sculpture's very top, concealed in the cavity behind Hugo's head and invisible to the viewer standing far below. *Iris*'s openly displayed pudenda were, it seems, Rodin's private joke, his sly, even Freudian revenge at the niggling constrictions of the Subcommittee for Works of Art.

Through the 1890s the government commissioned other sculptures for the Pantheon program, which shared the fate of the Hugo monument. After the commissions to Rodin and Injalbert, the subcommittee turned its attention to the statue of the Revolution that would stand in the Pantheon's

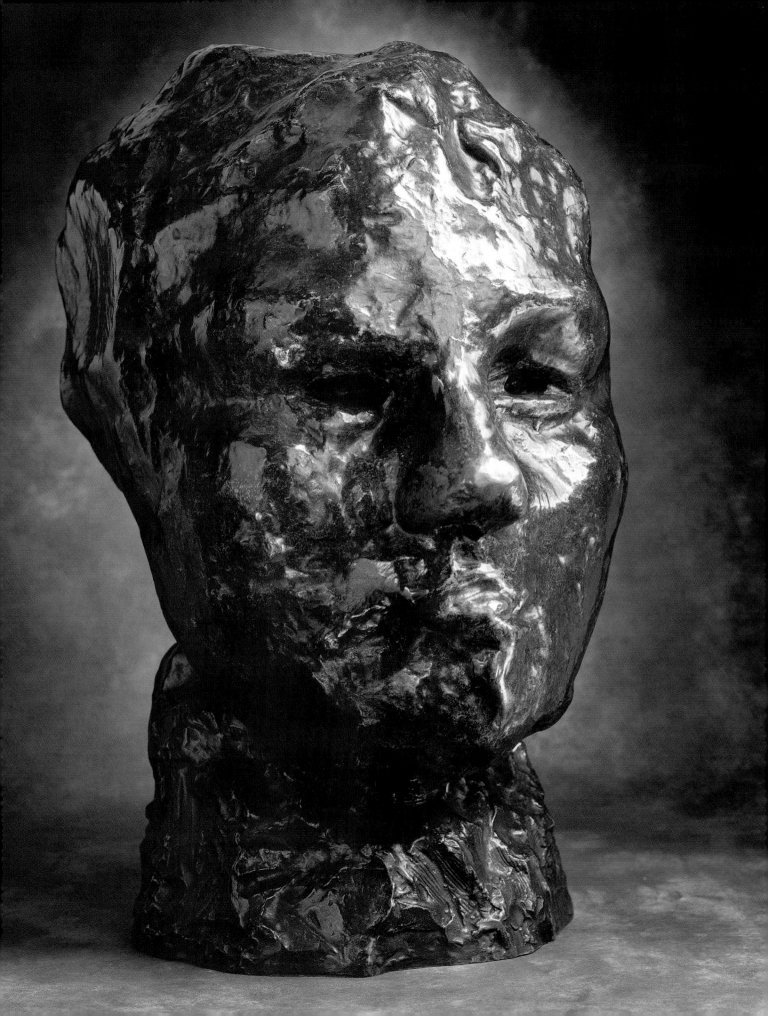

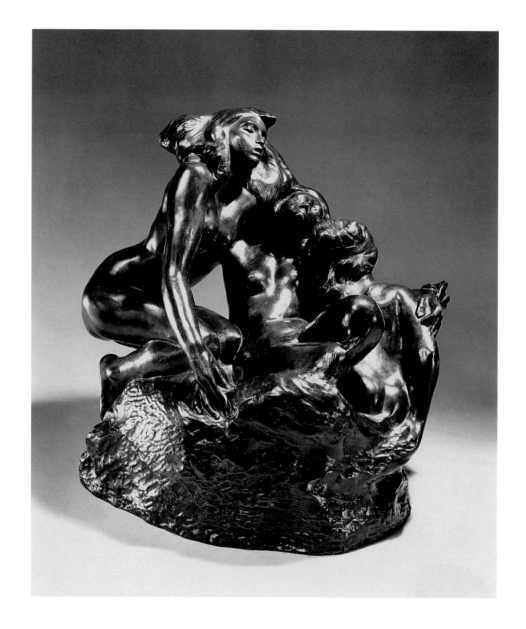

Figure 64 [catalogue no. 19]

AUGUSTE RODIN

France, 1840–1917

The Sirens

1880s, Musée Rodin cast 5/12, 1967

Bronze

17 × 17¹/₄ × 12⅝ in. (43.2 × 43.8 × 32.1 cm)

Inscribed below knees of middle figure: A. Rodin; also on lower edge, proper left: © by musée Rodin 1967

Foundry mark at back of base toward proper right: Georges Rudier Fondeur Paris

Brooklyn Museum of Art, Gift of the Iris and B. Gerald Cantor Foundation

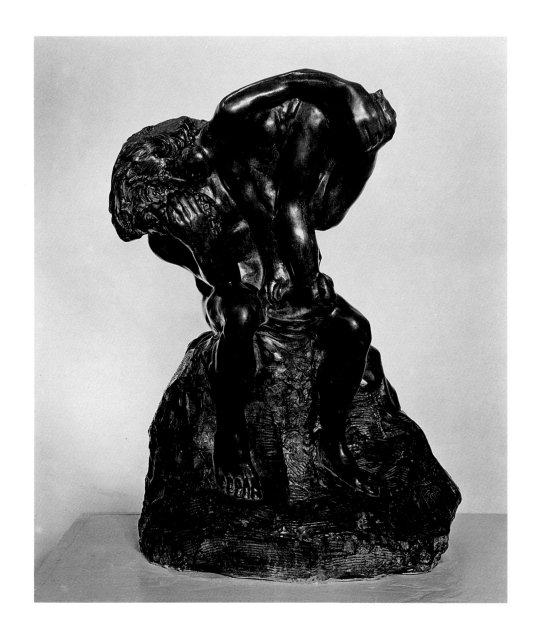

Figure 65 [catalogue no. 21]

AUGUSTE RODIN

France, 1840–1917

The Sculptor and His Muse

c. 1890

Bronze

$25^{15}/_{16} \times 18^{13}/_{16} \times 19^{15}/_{16}$ in. (65.9 × 47.8 × 50.6 cm)

Inscribed on front of base, proper right: A. Rodin; stamped inside front: A. Rodin

Foundry mark on back, lower right: ALEXIS. RUDIER./.FONDEUR.PARIS.

The Fine Arts Museums of San Francisco, Gift of Alma de Bretteville Spreckels, 1941.34.2

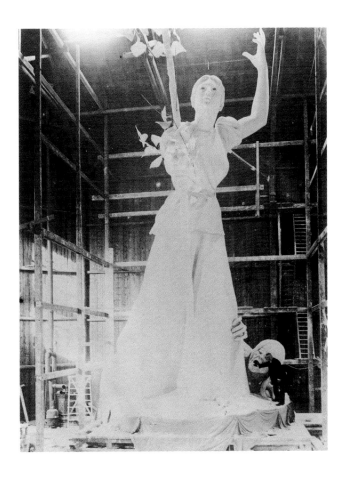
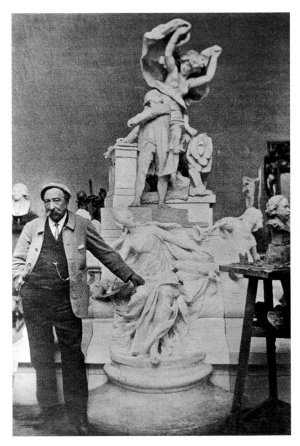

apse. In this case they first tried to design the sculpture themselves, sketching out their ideas and having them tested in the Pantheon in painted simulations. However, although they made two such attempts at "art by committee," the results were apparently disastrous, and the subcommittee agreed, reluctantly but unanimously, to leave to the sculptor the formation of the design.[72] Alexandre Falguière was chosen to execute the monument, and to make another very long saga short, he, like Rodin, settled on a colossal-sized sculpture. When Falguière constructed a full-scale model of it (figure 66), some forty feet high, it was rejected by the subcommittee in 1897. Characterized by Alexandre as "stupefying!" the project had gone no further at Falguière's death in 1900.

Also undertaken was a monument to the orators of the Restoration, a commission that was given to Chapu. When he died three months later, the commission was given to Dalou, the man who had so clearly set forward his ambition for the monument to Hugo. Dalou's commission was paired with a statue commemorating the generals of the Revolution, and when the two

Figure 66

A. BARRIER

Alexandre Falguière with full-scale study for his Monument to the Revolution

1897
Photograph
Paris, Musée Rodin
Photo: © Musée Rodin

Figure 67

Jean-Antonin Injalbert (France, 1845–1933) with study for his Monument to Mirabeau

no date
Photograph
Photo: Author's Photo

Figure 68 (overleaf) [catalogue no. 9]

AUGUSTE RODIN

France, 1840–1917

The Monument to Victor Hugo

Large model incomplete 1897;
definitive model completed shortly
after 1900; Musée Rodin cast 1/8,
1996
Bronze
$72^{3}/_{4} \times 112^{1}/_{8} \times 63^{3}/_{4}$ in.
(184.8 × 310 × 162.6 cm)
Inscribed on base, proper left, below
foot of Victor Hugo: A. Rodin N⁰ 1/8
Foundry mark on back, proper right:
Fonderie de Coubertin France © By
musée Rodin 1996
Iris and B. Gerald Cantor Foundation
(Photo by Meidad Suchowolski)

projects came before the subcommittee in 1898, the group requested revisions, claiming once again that there was too great a dissimilarity in format between monuments that should function as each other's complement. At this point both sculptors seem to have put down their chisels and ceased work on their Pantheon projects.[73]

In the end the government lost interest in the Pantheon program of 1889. Too much money had been spent in stalled or aborted projects, and in the political turmoil of *fin-de-siècle* France, the once grandiose and revolutionary program was allowed to fade from the nation's consciousness. The sculptures that stand now in the Pantheon's space came from later, twentieth-century projects, and all that was ever executed from the program of 1889 was a lone statue of Mirabeau, which had been excerpted from Injalbert's *fla-fla décoratif* (figure 67).

EPILOGUE

By the later twentieth century the prejudices of ancestors have faded considerably, and with the passage of time we have reversed many of the verdicts of the 1890s. In 1964 the *Monument to Victor Hugo*, as Rodin had conceived it in plaster in 1897, was cast in bronze and placed at the intersection of the avenues Victor-Hugo and Henri-Martin (figure 69). In 1995 the Iris and B. Gerald Cantor Foundation, working with the Musée Rodin, commissioned a second bronze cast, executed by the firm of Coubertin in Paris (figure 68). With the making of these casts, Rodin's *Monument to Victor Hugo* has been released from the strangling narrow-mindedness of so many *ronds-de-cuir* and *pontifes* and freed from the political and aesthetic controversies that thwarted its realization in the 1890s. Thus decontextualized, it has been rescued from obscurity and can be seen by a new public, no longer threatened by the shock that Rodin's sculpture provides. It was at the beginning of the twentieth century that Edward Steichen made his journey to Paris and singled out *The Monument to Victor Hugo* as the background for his portrait of Rodin, and it is now at the century's end that we can appreciate the significance, and the felicity, of Steichen's choice.

I leave the last words about Rodin's monument to Gustave Geffroy, who had been such a staunch defender of the project all through the 1890s. When Rodin organized his retrospective of 1900, the exhibition that so moved Steichen, Geffroy was among the writers who contributed to Rodin's catalogue. About the *Monument to Victor Hugo*, he wrote one of the most

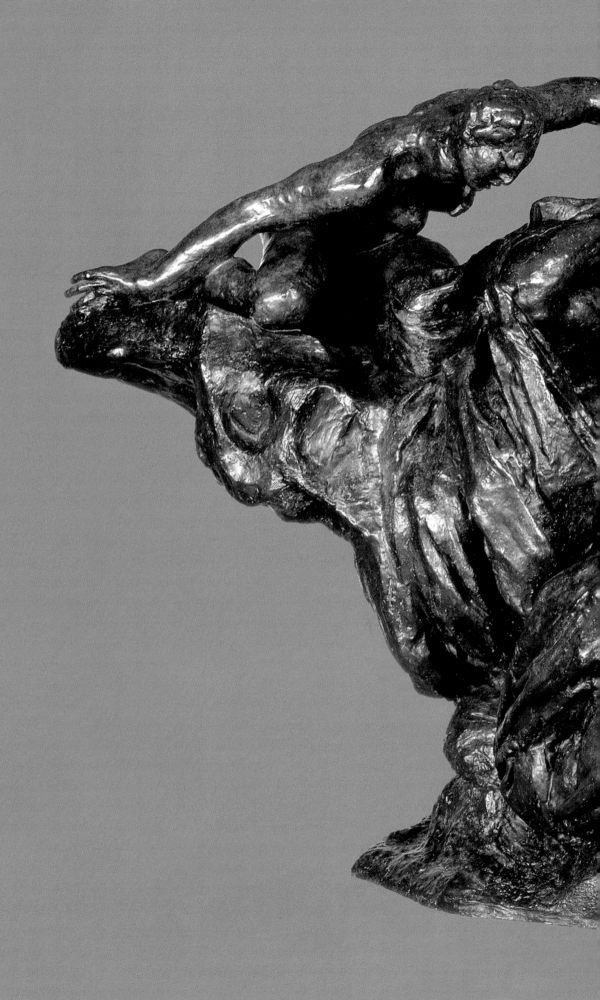

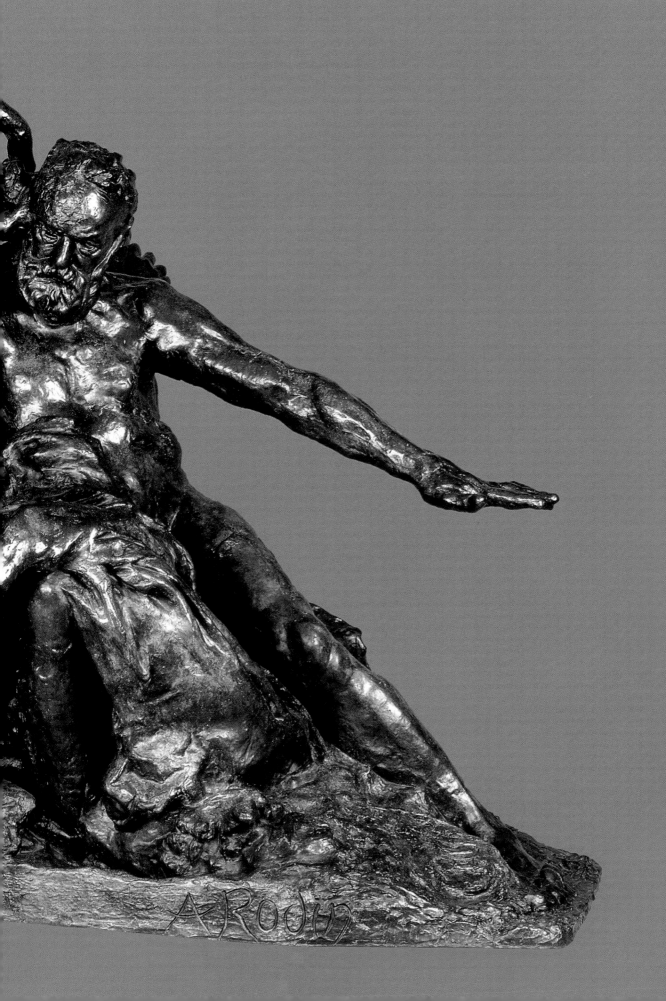

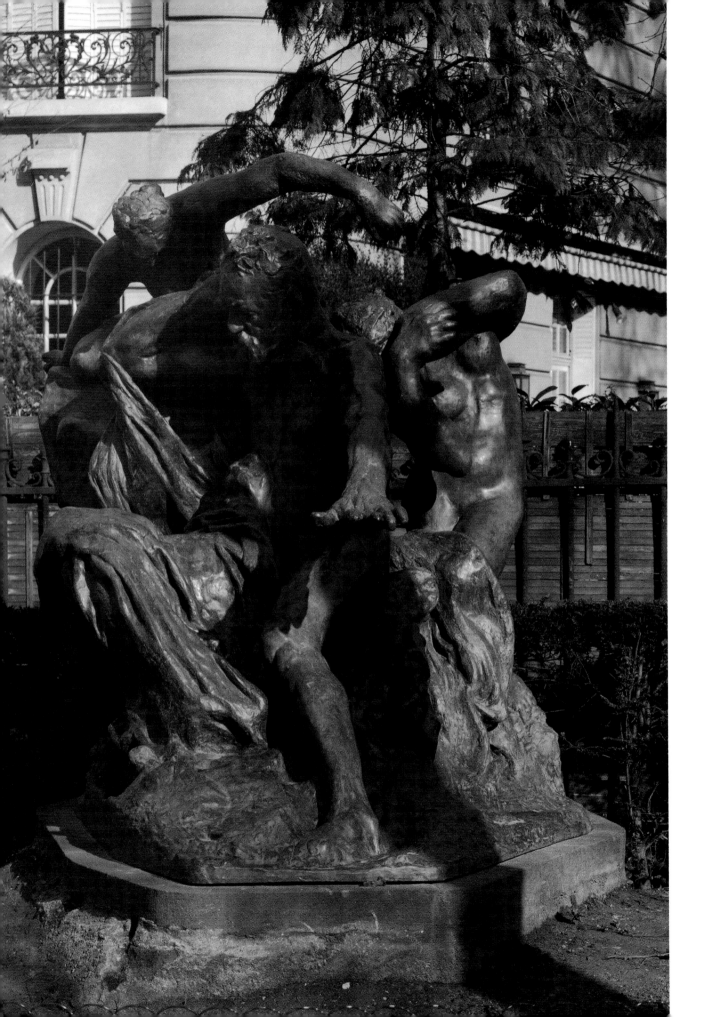

beautifully impassioned and thoughtful descriptions of the sculpture, expressed in the vivid, enspiriting, voluptuous prose of Rodin's and Hugo's time:

The poet, nude as a god, powerful as a giant, is seated at the edge of the sea, among the rocks where the first waves break. He has in front of him the abyss, which he contemplated for twenty years, from the promontories of Jersey and Guernsey, the vast sea sculpted by the wind, changing, tinted with color, terrible and graceful, the Ocean toward which his thoughts always go

Inspiration comes toward him. He listens to the voices that the waves and the air carry to him. A woman swoops down on the rock, above his head, with the movement of a hurricane. Another rises behind him in the foam of the waves. The one is virile and untamable, she speaks and sings in a loud voice: this is the muse of history, of legend, of anger; she has wandered the earth and she brings with her the protests and revolts of humanity. The other is gentle, melancholic, and enchanting; her body, youthful and fresh, is impregnated with the water of the sea, and it is she who murmurs and whispers the soft words that are brought by the babbling waves, that rustle in the verdant river banks and that are sung by children, young women, and lovers.

Rodin has made his idea visible for everyone. These two women are not apparitions. They are voices. The poet does not look at them. He listens to them, while space unfolds in front of him, and never has the double action of a physiognomy been better expressed: the eyes, small, alive, deep, give off an extraordinary power of vision, while attention, reflection take hold of the face, giving to the body that attitude of strength to the point of abandonment. Interior life manifests itself through the body's repose, through the brow bent and inclined forward, and through the beautiful, instinctive gesture of the extended hand.[74]

Figure 69
AUGUSTE RODIN
France, 1840–1917

The Monument to Victor Hugo
Bronze
Large model incomplete 1897; definitive model completed shortly after 1900; this cast begun c. 1952, unveiled 1964
72³/₄ × 112¹/₈ × 63³/₄ in.
(184.8 × 310 × 162.6 cm)
Paris, avenue Henri-Martin
Photo: © Musées de la Ville de Paris

NOTES

Much of the research for this essay formed part of my doctoral dissertation, "Rodin, Hugo, and the Pantheon: Art and Politics in the Third Republic," completed at Columbia University, New York, in 1981; and some of the material appeared, in different form, as "Rodin's *Monument to Victor Hugo*," *Art Bulletin* 68, no. 4 (December 1986), pp. 632–56. It is my pleasure to acknowledge the contributions of Theodore Reff and Kirk Varnedoe, who guided my graduate work in ways for which I am ever grateful, and to give special thanks to Kirk, who brought my research to the attention of the Cantor Foundation. Mrs. Iris Cantor, Rachael Blackburn, Danna Freedy, and Brandy Sweeney have beautifully and generously facilitated the writing of this essay; while my fellow contributors, Ruth Butler and Jeanine Plottel, have shared their knowledge with an enspiriting open-handedness and a real sense of camaraderie. Valerie Moylan, painter, scholar, and graduate assistant *par excellence*, has been warmth and professionalism personified, while

Mitch Tuchman, an especially wise and thoughtful editor, has removed from the text any number of *gaffes* about which, fortunately, only he will know. At the Musée Rodin in Paris, Anne-Marie Barrère, Marie-Pierre Delclaux, and Sylvester Engbrox contributed their archival and photographic expertise. As for Hélène Pinet, *chargée des collections de photographies* at the Musée Rodin, Alison Heydt Tung, Sally Webster, Jean Kashmer, Bill Griesar, and Katherine Roos: *merci infiniment.*

1. Edward Steichen, *A Life in Photography* (London: W.H. Allen, 1963), unpag. See also Ruth Butler, *Rodin: The Shape of Genius* (New Haven: Yale University Press, 1993), pp. 405–07; Edward Steichen, "Rodin's Balzac," *Art in America* 57, no. 5 (September 1969), pp. 25–27; Penelope Niven, *Steichen: A Biography* (New York: Clarkson Potter, 1997), pp. 106–27. In an undated letter to Alfred Stieglitz, probably written between 1901 and 1903, Steichen remarked that Rodin "took <u>my hand in big silence</u> the first time he went through my portfolio" (Alfred Stieglitz/Georgia O'Keeffe Archive, Beinecke Rare Book and Manuscript Library, Yale University; underline in original). In 1914 Steichen changed the spelling of his first name from Eduard to the Americanized Edward; however, though he was still technically Eduard in 1901, I have used the later, more familiar spelling to avoid confusion.

In the years around the turn of the century many of the people who play central roles in this essay were struck by the bicycle craze. In addition to Steichen, who had brought his bicycle from the United States and rode everywhere when he was in France, Rodin apparently owned two expensive bicycles, which he acquired in exchange for one of his sculptures. He never quite got the hang of riding them, though (see Butler, *Rodin*, p. 315). Gustave Larroumet, who would commission the monument, was also a fan of the bicycle. According to Edmond de Goncourt, Larroumet had great troubles learning how to ride; when he bicycled over to dinner one night, he confessed that he "he fell a lot, that he was covered with bruises, but that it amused him" (Edmond and Jules de Goncourt, *Journal: Mémoires d'une vie littéraire*, vol. 3 [Paris: Robert Laffont, 1989], p. 999 [entry for August 2, 1884]).

2. Steichen's photograph of Rodin was widely reproduced in the early twentieth century. A magazine clipping in the Stieglitz archive stated that it was "regarded by competent critics as the finest photograph ever taken," from "Inspired Photography – A New Art," undated press clipping from the journal *Literature and Art*, p. 645; Alfred Stieglitz/Georgia O'Keeffe Archive, Beinecke Rare Book and Manuscript Library, Yale University.

3. Compare Steichen's photograph with Rodin's *Monument to Victor Hugo* as seen, for example, in figures 45–47.

4. Hugo's characterization opposes "Napoleon the Small" to the first Napoleon, known as "Napoleon the Great." In 1852 Hugo published a vituperative pamphlet entitled *Napoléon le petit*.

5. Quoted in Graham Robb, *Victor Hugo: A Biography* (New York: W.W. Norton, 1998), p. 373.

6. Joseph Reinach, in *La Revue politique et littéraire*; article reprinted in *Victor Hugo devant l'opinion: Presse française – presse étrangère* (Paris: Office de la presse, 1885), p. 112.

7. In "L'Homme a ri," this line, the last in the short poem, reads, "*Mais je tiens le fer rouge et vois ta chair fumer.*" Here, Hugo has used the familiar form of the pronoun

Figure 70
AUGUSTE RODIN
France, 1840–1917

Victor Hugo

White marble
c. 1880s–1910
41½ × 41⅞ × 27½ in.
(105.4 × 106.4 × 69.8 cm)
Inscribed on back of base, proper left:
3886 (probably a quarry number)
The Fine Arts Museums of San
Francisco, given anonymously,
1962.28

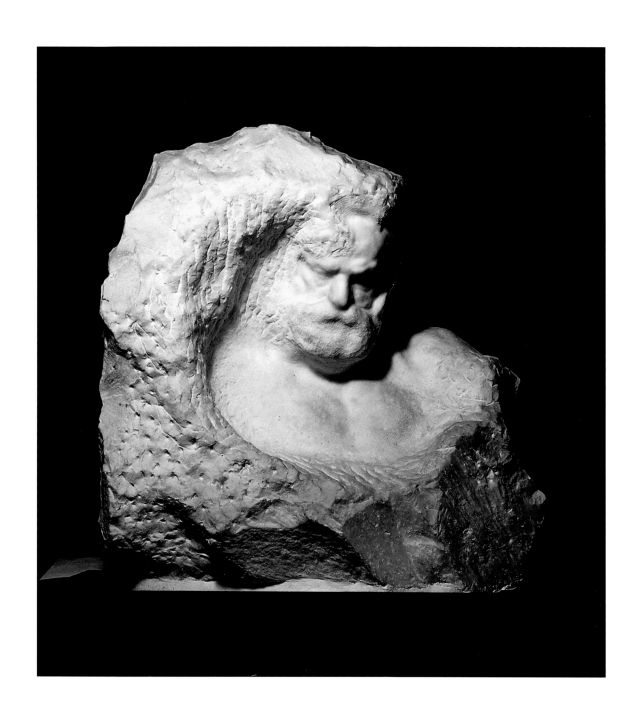

you, which in this context is meant to demean and insult. The verb *fumer* carries more connotations than the English *fume*; in addition to indicating that the flesh is smoking/smoldering and that Napoleon III is irritated, *fumer* suggests the spreading of manure. *Les Châtiments* was published in Belgium in 1853, and it would not be issued legally in France until the fall of Napoleon III.

8. See Robb, *Hugo*, p. 470.

9. For a description of the celebration of Hugo's birthday, see Robb, ibid., pp. 513–16; *La Gloire de Victor Hugo*, exh. cat. (Paris: Réunion des musées nationaux, 1985), pp. 283–85.

10. From an article in *Le XIX^e Siècle*; reprinted in *Beaumarchais: Journal satirique, littéraire et financier*, 6 March 1881, pp. 8–9.

11. This sculpture was Rodin's *Man with the Broken Nose* (1863–64); see Butler, *Rodin*, 1993, pp. 41–48; and Alain Beausire, *Quand Rodin exposait*, exh. cat. (Paris: Éditions Musée Rodin, 1988), p. 53.

12. *The Age of Bronze* was exhibited in plaster at the Salon of 1877 and in bronze at the Salon of 1880; a bust of *Saint John the Baptist* was exhibited in 1879 and a plaster of the full statue in 1880. For a thorough accounting of Rodin's exhibited works see Beausire, *Quand Rodin exposait*.

13. Because the government agency that regulated the fine arts changed its name frequently through the later years of the nineteenth century – being variously called the Ministry of Fine Arts, the Ministry of Public Instruction and Fine Arts, or the Ministry of Public Instruction, Cults, and Fine Arts – I have adopted the generic term ministry of fine arts and left it without capitalization.

14. On Turquet, Chennevières, and Rodin see Butler, *Rodin*, pp. 118–23, 137–49. See also Roos, "Aristocracy in the Arts: Philippe de Chennevières and the Salons of the Mid 1870s," *Art Journal* 48, no. 1 (spring 1989), pp. 53–62; "Herbivores versus Herbiphobes: Landscape Painting and the State," in John House, ed., *Impressions of France*, exh. cat. (Boston: Museum of Fine Arts; and London: Hayward Gallery, 1995), pp. 49–51; and *Early Impressionism and the French State* (New York: Cambridge University Press, 1996). A forthcoming study by the present author, *Against the Modernist Grain: Philippe de Chennevières and Reactionary Fine-Arts Policy in Nineteenth-Century France*, will consider Chennevières's enormous influence on government policy throughout the second half of the nineteenth century.

15. Henri-Charles-Étienne Dujardin-Beaumetz, "Rodin's Reflections on Art," trans. Ann McGarrell, in *Auguste Rodin: Readings in His Life and Work*, ed. Albert Elsen (Englewood Cliffs NJ: Prentice-Hall, 1965), p. 169.

16. Ibid., pp. 169–70. In quoting this material, I have used what I assume to have been the French word *hôtel* in place of the English *hotel*, because the former carries the connotation of a large private residence.

17. Interview with Rodin, in *Le Gaulois*, 25 September 1909; quoted in Catherine Lampert, *Rodin: Sculpture and Drawings*, exh. cat. (London: Arts Council of Great Britain, 1986), p. 106. See also *Rodin et les écrivains de son temps: Sculptures, dessins, lettres, et livres du fonds Rodin*, exh. cat. (Paris: Musée Rodin, 1976), pp. 78–88.

18. Butler, *Rodin*, p. 175; Lampert, *Rodin*, pp. 201–02, 217–18.

19. "Portrait of an old chiseler," from *Annales politiques et littéraires*, 2 December 1917, press clipping, archives of the Musée Rodin, Paris; Goncourt, *Journal*, vol. 3, p. 84. Although Edmond Bazire, a mutual friend of Rodin and Hugo, assured the sculptor that his bust was indeed beloved by "everyone" in the Hugo household,

Bazire's letter seems to have been prompted by the fact that the news had spread that the work was not universally admired among Hugo's circle (Bazire to Rodin, undated [c. 1884], archives of the Musée Rodin, Paris).

20. On the Pantheon and its history see Pierre Chevallier and Daniel Rabreau, *Le Panthéon* (Paris: Caisse nationale des monuments historiques et des sites, 1977); and *Les Grands Hommes du Panthéon* (Paris: Éditions du patrimoine, 1996). Also informative is Philippe de Chennevières, *Les Décorations du Panthéon* (Paris: Aux bureaux de *L'Artiste*, 1885).

21. Reports and approval by the minister (28 February 1874), Archives nationales, F[21] 4403.

22. Decree creating the program, signed 12 February 1889, Archives nationales, F[21] 4404; reprinted in *Le Journal officiel de la République française*, 14 February 1889: pp. 794–95. During this period *Le Journal officiel* was the French newspaper of record.

23. The "waltz of the ministries" is a phrase used by Jean-Marie Mayeur, in *Les Débuts de la Troisième République 1871–1878* (Paris: Éditions du Seuil, 1973), p. 166.

24. Lockroy actually set up two committees: the first a forty-member Committee for Works of Art, which would advise the administration on matters relating to the fine arts; the second, a twelve-member subcommittee, drawn from the larger group, which would study in depth such projects as the Pantheon program.

25. Charles Bigot, "Causerie artistique: Les Commandes de l'État," *Le Siècle*, 23 February 1889, press clipping, Archives nationales, F[21] 4758.

26. The literature on Rodin, and the files of the Musée Rodin in Paris, suggest that the administration had begun to discuss with Rodin a monument to Hugo for the Pantheon well before the program was formulated and announced. Both Judith Cladel, in *Rodin: Sa vie glorieuse, sa vie inconnue*, definitive edn. (Paris: Bernard Grasset, 1950), pp. 172–73; and Frederick Lawton, in *The Life and Work of Auguste Rodin* (London: T. Fisher Unwin, 1906), p. 258, refer to an early commission to Rodin, given (Cladel) or "informally made" (Lawton) around 1886. A note from Larroumet to Rodin, 4 February 1889, refers to a project that they had previously discussed, which was about to become a reality (Archives du Musée Rodin, Paris, dossier Larroumet).

27. The Subcommittee for Works of Art included the following people:

Philippe de Chennevières;

Jules Comte, who served as the director of civil buildings and national palaces;

Eugène Guillaume, who was a sculptor, a former director of the École des beaux-arts, and a former director of fine arts (1878–79); he would go on to head the French Academy in Rome;

Albert Kaempfen, who had been the director of fine arts from 1882 to 1887 and who was now the director of the national museums and of the École du Louvre;

Georges Lafenestre, a curator at the Louvre;

Paul Mantz, who had been the director of fine arts in 1882 and now held the title of honorary general director of fine arts;

Charles Yriarte, Philippe Burty, and Henry Havard, art critics who were now inspectors of fine arts.

In addition to these nine administrators, plus Larroumet, there were seven artists or architects, as mentioned here in the text. The eighteenth member was a man by the name of Baumgart, who ran one of the offices in the administration and served as

the subcommittee's secretary. Information on the committee and subcommittee was taken from *Le Journal officiel*, 14 February 1889: pp. 793–95; Archives nationales, F[21] 4758; and Gustave Larroumet, *L'Art et l'État en France* (Paris: Hachette, 1895).

28. *La Sculpture française au XIX^e siècle*, exh. cat. (Paris: Réunion des musées nationaux, 1986), p. 342.

29. Minutes of the subcommittee's meetings, from which this account was summarized, are located in Archives nationales, F[21] 4758.

30. "My first friend," quoted in Butler, *Rodin*, p. 164. An excellent summary of Dalou's career, written by John M. Hunisak, appears in Peter Fusco and H.W. Janson, eds., *The Romantics to Rodin: French Nineteenth-Century Sculpture from North American Collections*, exh. cat. (Los Angeles: Los Angeles County Museum of Art, in association with George Braziller, 1980), pp. 185–99.

31. A description of Dalou's sculptures appeared in André Michel, "Le Salon de 1886," *Journal des débats*, 17 June 1886, press clipping, archives of the Musée Rodin, Paris.

32. Minutes, 12 June 1889, Archives nationales, F[21] 4758.

33. Gustave Larroumet, "Rapport au ministre," 10 September 1889, Archives nationales, F[21] 4758; reprinted in Larroumet, *L'Art et l'Etat*, 1895, pp. 335–41.

34. Larroumet, 10 September 1889, p. 11.

35. The commissions to Rodin and Injalbert were signed on 16 September 1889; Archives nationales, F[21] 4223 (Injalbert) and F[21] 4264 (Rodin). Rodin responded with a short letter to the ministry in which he expressed his delight: "Very happy with the magnificent commission that you have just had given to me, the *Monument to Victor Hugo*." Rodin thought that the maquette would be finished in about a month and asked for additional space in the Dépôt des Marbres because *The Gates of Hell* occupied all of the space in his current studio. Rodin to Larroumet, 24 September 1889, Archives nationales, F[21] 4264.

36. Beausire, *Quand Rodin exposait*, pp. 99–106; *Exposition Universelle de 1889 à Paris: Catalogue général officiel*, vol. 1 (Lille: L. Daniel, 1889); Galerie Georges Petit, *Claude Monet. A. Rodin* (Paris: E. Ménard, 1889).

37. Larroumet, 10 September 1889, pp. 10–11. In this report Larroumet described Rodin's monument as follows: "M. Rodin has chosen, for his monument, the Victor Hugo of the exile, he who had the constancy to protest for eighteen years against the despotism that had chased him from the homeland. He considered that the great poet had never possessed the more complete plenitude of his genius than during that period, when he rediscovered the most graceful, as well as the most intense, inspirations of his youth, joining to them the genius of political invective and the expression of the most profound human pity. He thus represented him seated on the rocks of Guernsey; behind him, in the curl of a wave, the three muses of Youth, Maturity, and Old Age whisper inspiration to him."

The same document included a description of Injalbert's monument to Mirabeau, which seems, from the beginning, to have been planned for a different format altogether: "M. Injalbert proposes to represent Mirabeau at the tribune, at the moment when the great orator finishes the speech that was his supreme victory and that drained all of his strength and preceded his death by several days. At the foot of this tribune, the new France listens and awakes to liberty, the nation's three estates gather together in a fraternal embrace, and, behind the orator, Eloquence inspires and sustains him." (pp. 10–11).

38. On Hugo's beard, see *La Gloire de Victor Hugo*, esp. pp. 65–87.

39. Rodin to Larroumet, 24 March 1890, Archives nationales, F[21] 4264. A further indication of Rodin's uneasiness with specific designations for the figures of the muses is indicated in this letter, which shows that he had first written that the muse on the right represented *Les Orientales* and that on the left was "the most ideal." He then crossed out "right" and replaced it with "left" and *vice versa*.

40. The description of Injalbert's monument was taken from a letter from the sculptor to the administration of fine arts (undated, but received by the office on "29 March 1890"), Archives nationales, F[21] 4223.

41. Minutes, 27 March 1890, Archives nationales, F[21] 4758.

42. Documents relative to the creation of these painted facsimiles are found in Archives nationales, F[21] 4264, F[21] 4404, and F[21] 4758; and in the archives of the Musée Rodin, Paris.

43. Comments from *La France*, reprinted in René Lavoix, *Le Siècle*, 19 July 1890; Archives nationales, F[21] 4404. The members of the subcommittee who attended the session in the Pantheon were "MM. Ballu, Chapu, Bailly, Dalou, Mantz, Garnier, Yriarte, Havard, Lafenestre"; minutes, 10 July 1890, Archives nationales, F[21] 4758. That the facsimile of Rodin's monument was half the size of that of Injalbert is indicated on the budget listings to be found in Archives nationales F[21] 4404.

44. Garnier's views on sculpture's necessarily subservient role had caused serious problems for Jean-Baptiste Carpeaux's *The Dance*, designed for the Paris Opéra in the late 1860s.

45. Minutes, 10 July 1890, Archives nationales, F[21] 4758.

46. Press clipping, Archives nationales, F[21] 4404.

47. Remarks in *La France*, reprinted in Lavoix, *Le Siècle*, 19 July 1890, press clipping, Archives nationales, F[21] 4404. The three other newspapers were *Le XIX^e Siècle*, *Le Temps*, and *La France*.

48. Press clipping, Archives nationales, F[21] 4404.

49. Press clipping, archives of the Musée Rodin, Paris.

50. Press clipping, Archives nationales, F[21] 4404.

51. Press clipping, archives of the Musée Rodin, Paris.

52. Press clipping, archives of the Musée Rodin, Paris.

53. Press clipping, Archives nationales F[21] 4404.

54. Commenting to a reporter that such a step would create "an unfortunate precedent," Larroumet hypothesized that some of the subcommittee's members would resign if he or the minister were to override the decision of July 10. Comment reported by René Lavoix, in *Le Siècle*, 19 July 1890, press clipping, Archives nationales, F[21] 4404.

55. The new commission was officially given Rodin at the end of 1891; it specified a marble monument to Victor Hugo but left the question of the site open, stating that the monument would "be placed in a Museum or in a public garden." Commission (back-dated to June 19, 1891) and Larroumet to Rodin, 6 October 1891, dossier Larroumet, archives of the Musée Rodin, Paris; draft of the letter, Archives nationales, F[21] 2189.

56. A letter from Rodin to Larroumet (28 December 1890) implies that the terra-cotta was executed at the end of 1890; Archives nationales F[21] 2189. Larroumet

apparently had a genuine admiration for the work, which he used in 1895 as the frontispiece to a book about Hugo's years on Guernsey. Gustave Larroumet, *La Maison de Victor Hugo: Impressions de Guernesey* (Paris: H. Champion, 1895).

57. On the viewer's engagement of a work of art see Ellen Handler Spitz, *Art and Psyche: A Study in Psychoanalysis and Aesthetics* (New Haven: Yale University Press, 1985), esp. pp. 158–65.

58. Arsène Alexandre, "Introduction au catalogue," *Exposition Rodin*, exh. cat. (Paris: Société d'Édition artistique, 1900), p. xvi.

59. On Rodin's politics see Butler, *Rodin*, esp. pp. 287, 321–26, and 542 n. 33.

60. On this period in Rodin's life see the illuminating discussion ibid., pp. 284–329.

61. Goncourt, *Journal*, vol. 3, p. 1152 (entry for 6 July 1885).

62. Report by Armand Silvestre, 6 January 1894, Archives nationales, F^{21} 4338.

63. Ibid., Archives nationales, F^{21} 4264.

64. Correspondence between Rodin and the administration, Archives nationales, F^{21} 2189.

65. Number 125, Société Nationale des beaux-arts, *Catalogue des ouvrages de peinture, sculpture, dessins ...* (Paris: Evreux, 1897), p. 257.

66. Georges Lafenestre, "Les Salons de 1897," *La Revue des deux mondes* 142, no. 2 (1 July 1897): p. 189.

67. Quoted in Robb, *Hugo*, p. 343.

68. Widely publicized in the press, the incident came to the attention of Steichen in Milwaukee and was one of the factors that drew him to Paris in 1900.

69. Documents concerning this sculpture, the version of the Hugo monument depicting the poet in a standing position, are located in Archives nationales, F^{21} 2189, F^{21} 4264, F^{21} 4404, and F^{21}4758; and in the archives of the Musée Rodin, Paris. Rodin's maquette was reproduced in *L'Illustration*, 26 December 1891.

70. A comment in the minutes of a meeting of the subcommittee on December 17, 1891, noted that "M. Yriarte ... expressed certain fears in regard to the criticisms to be made to the artist, fears that are inspired in him by the very great notoriety of the latter [Rodin] and because of the popularity so justified that he enjoys in the world of the press, and finally because of the clamor that has arisen around this work"; Archives nationales, F^{21} 4758.

71. The main documents for the colossal version of Rodin's sculpture are located in Archives nationales, F^{21} 4338 and F^{21} 4404; and in the archives of the Musée Rodin, Paris.

72. Documents for the monument to the Revolution are to be found in Archives nationales, F^{21} 2078, F^{21} 4404, and F^{21} 4758.

73. Archives nationales, F^{21} 2164B, F^{21} 4246, and F^{21} 4404 contain the documents relevant to the commissions to Chapu and Dalou. Interesting to note is that Chapu's death in 1891 resulted not only in Dalou's receiving the commission for the Pantheon but also in Rodin's receiving the commission for a monument to Balzac from the Société des gens de lettres.

74. Gustave Geffroy in *Exposition Rodin*, exh. cat. (Paris: Société d'Édition artistique, 1900), pp. 18–19.

Exhibition Checklist

Auguste Rodin
France, 1840–1917

Catalogue no. 1
Head of Victor Hugo
c. 1883
Terra-cotta
6³/₄ × 4³/₈ × 5³/₈ in.
(17.5 × 11 × 13.5 cm)
Paris, Musée Rodin

Catalogue no. 2
Bust of Victor Hugo
1883, date of cast unknown
Bronze
17 × 10¹/₄ × 10³/₄ in.
(43.2 × 26 × 27.3 cm)
Inscribed on base, proper
right: A. Rodin
No foundry mark
Iris and B. Gerald Cantor
Collection

Catalogue no. 3
Victor Hugo
1884
Drypoint
8³/₄ × 15¹⁵/₁₆ in. (22.2 × 40.5 cm)
Los Angeles County Museum
of Art, Gift of B. Gerald
Cantor Foundation

Catalogue no. 4
Victor Hugo
1886
Drypoint
8³/₄ × 6¹/₂ in. (22.2 × 16.5 cm)
Iris and B. Gerald Cantor
Foundation

Catalogue no. 5
Head of Victor Hugo
1886, date of cast unknown
Bronze
7³/₄ × 4 × 5¹/₄ in.
(19.7 × 10.2 × 13.3 cm)
Inscribed on neck, proper left:
A. Rodin
Foundry mark on neck, proper
right: Alexis Rudier Fondeur
College of the Holy Cross,
Worcester, Massachusetts,
Gift of Iris and B. Gerald
Cantor

Catalogue no. 6
*Maquette for The Monument to
Victor Hugo*
c. 1889–90
Bronze
15 × 11³/₈ × 14¹/₈ in.
(38.2 × 29 × 36 cm)
Inscribed on back: Rodin
Foundry mark: Griffoul et
Lorge fondeur, Paris.
6 passage Dombasle
Paris, Musée Rodin

Catalogue no. 7
The Apotheosis of Victor Hugo
1890–91, cast 1925–26
Bronze
44 × 20¹/₄ × 24 in.
(111.8 × 51.4 × 61 cm)
Inscribed on base, proper
right: A. Rodin
Foundry mark on base, back
proper left: ALEXIS RUDIER
M R/Fondeur. PARIS. Nº 1
Bequest of Jules E. Mastbaum;
Rodin Museum, Philadelphia

Catalogue no. 8
*Nude Study for The Monument
to Victor Hugo*
c. 1893–94
Plaster
34⁵/₈ × 32 × 30³/₈ in.
(88.4 × 81.6 × 77.1 cm)
Inscribed on base: Première
épreuve
Paris: Musée Rodin

Catalogue no. 9
The Monument to Victor Hugo
Large model incomplete 1897;
definitive model completed
shortly after 1900; Musée
Rodin cast 1/8, 1996
Bronze
72³/₄ × 112¹/₈ × 63³/₄ in.
(184.8 × 310 × 162.6 cm)
Inscribed on base, proper left,
below foot of Victor Hugo:
A. Rodin Nº. 1/8
Foundry mark on back, proper
right: Fonderie de Coubertin
France © By musée Rodin
1996
Iris and B. Gerald Cantor
Foundation

Catalogue no. 10
Heroic Bust of Victor Hugo
1890–97 or 1901–02, Musée
Rodin cast 5/12, 1967
Bronze
27³/₄ × 18³/₄ × 18³/₄ in.
(70.5 × 47.6 × 47.6 cm)
Inscribed on torso, proper left:
A. Rodin; below this, on
support: © by musée
Rodin.1967.
Foundry mark on back of
proper right shoulder:
.Georges Rudier./
.Fondeur.Paris.
Los Angeles County Museum
of Art, Gift of B. Gerald
Cantor Art Foundation

Catalogue no. 11
Head of Victor Hugo
no date
Marble
18$\frac{1}{2}$ × 8$\frac{3}{8}$ × 7$\frac{7}{8}$ in.
(47 × 21 × 20 cm)
Paris, Musée Rodin

Catalogue no. 12
Meditation (without Arms)
1884–85, enlarged 1895–96,
Musée Rodin cast 6/8, 1983
Bronze
57$\frac{1}{2}$ × 28 × 22$\frac{1}{8}$ in.
(146.1 × 71.1 × 56.2 cm)
Inscribed on base to right of
figure's proper left leg: A.
Rodin N\underline{o} 6/8; also at bottom
back of base: © By musée
Rodin 1983
Coubertin foundry mark to the
left of second inscription: FC
with rising sun (in relief)
Iris and B. Gerald Cantor
Collection

Catalogue no. 13
Meditation (with Arms)
Originally conceived for *The
Gates of Hell*, c. 1885–87;
separated from definitive
Monument to Victor Hugo as an
independent sculpture shortly
after 1900; Musée Rodin cast
9, 1980
Bronze
61 × 25 × 25 in.
(159.4 × 63.5 × 63.5 cm)
Inscribed on base, below
proper left foot: A. Rodin
N\underline{o} 9; on left side of base:
© by musée Rodin 1980
Coubertin foundry mark above
inscription to the right: FC
with rising sun (in relief)
Iris and B. Gerald Cantor
Foundation

Catalogue no. 14
Tragic Muse
1890–96, Musée Rodin cast
3/8, 1986
Bronze
13 × 25$\frac{1}{2}$ × 15$\frac{1}{4}$ in.
(33 × 64.8 × 38.7 cm)
Inscribed on rock base under
proper left foot: A Rodin; and
on side of base under proper
right hand: © BY MUSEE
Rodin 1986
Foundry mark on side of rock
base, under proper right foot:
E. GODARD FONDEUR
Iris and B. Gerald Cantor
Foundation

Catalogue no. 15
Head of the Tragic Muse
1890–96, Musée Rodin cast
5/12, 1979
Bronze
11$\frac{5}{8}$ × 7$\frac{1}{4}$ × 9$\frac{7}{8}$ in.
(29.5 × 18.4 × 25.1 cm)
Inscribed: on neck, proper left
side: A. Rodin N\underline{o} 5; on
bottom, proper left toward the
back: © by musée Rodin 1979
Foundry mark on back at
bottom: Georges Rudier
Fondeur Paris
Brooklyn Museum of Art, Gift
of the Iris and B. Gerald
Cantor Foundation

Catalogue no. 16
*Iris, Messenger of the Gods (with
Head)*
1890–91, Musée Rodin cast
1/12, 1969
Bronze
18 × 16 × 9$\frac{1}{2}$ in. (45.7 × 40.6 ×
24.1 cm)
Inscribed on sole of proper left
foot: A. Rodin No. 1; on back
of base block: © by musée
Rodin 1969
Foundry mark on base, proper
left: Susse Fondeur/Paris.
Iris and B. Gerald Cantor
Center for Visual Arts at
Stanford University
Gift of B. Gerald Cantor Art
Foundation

Catalogue no. 17
*Iris, Messenger of the Gods
(without Head)*
1890–1900, Musée Rodin cast
9/12, 1966
Bronze
31 × 35 × 14 in. (78.7 × 88.9 ×
35.6 cm) (without base)
Inscribed on sole of proper
right foot: A. Rodin; on base,
left: © by musée Rodin.1966
Foundry mark on base, back:
.Georges Rudier./.Fondeur.
Paris.
Los Angeles County Museum
of Art, Gift of B. Gerald
Cantor Art Foundation

Catalogue no. 18
Large Head of Iris
Possibly 1890–1900, enlarged
by 1909, Musée Rodin cast
4/12, 1967
Bronze
24 × 12 × 14$\frac{3}{4}$ in.
(61 × 30.5 × 37.5 cm)
Inscribed on base, right: A.
Rodin; at lower edge: © by
musée [*sic*] Rodin 1967
Foundry mark on base, left, at
lower edge: .Georges
Rudier./.Fondeur.Paris.
Los Angeles County Museum
of Art, Gift of B. Gerald
Cantor Art Foundation

Catalogue no. 19
The Sirens
1880s, Musée Rodin cast 5/12,
1967
Bronze
17 × 17$\frac{1}{4}$ × 12$\frac{5}{8}$ in.
(43.2 × 43.8 × 32.1 cm)
Inscribed below knees of
middle figure: A. Rodin; also
on lower edge, proper left:
© by musée Rodin 1967
Foundry mark at back of base
toward proper right: Georges
Rudier Fondeur Paris
Brooklyn Museum of Art, Gift
of the Iris and B. Gerald
Cantor Foundation

Catalogue no. 20
Jules Dalou
1883, cast 1925
Bronze
20$\frac{3}{4}$ × 16 × 7 in.
(52.7 × 40.6 × 17.7 cm)
Inscribed on proper left
shoulder front and on stamp
inside: A. Rodin
Foundry mark on rear proper
right shoulder: ALEXIS RUDIER/
Fondeur. PARIS.
Bequest of Jules E. Mastbaum;
Rodin Museum, Philadelphia

Catalogue no. 21
The Sculptor and His Muse
c. 1890
Bronze
25$\frac{15}{16}$ × 18$\frac{13}{16}$ × 19$\frac{15}{16}$ in.
(65.9 × 47.8 × 50.6 cm)
Inscribed on front of base,
proper right: A. Rodin;
stamped inside front: A. Rodin
Foundry mark on back, lower
right: ALEXIS.RUDIER./
.FONDEUR.PARIS.
The Fine Arts Museums of
San Francisco, Gift of Alma
de Bretteville Spreckles,
1941.34.2

Catalogue no. 22
The Genius of Sculpture
c. 1880–83
Brown ink and wash on brown
transparent paper
10$\frac{3}{8}$ × 7$\frac{1}{2}$ in. (26.4 × 19.1 cm)
Inscribed: la genie de la
Sculpture/A. Rodin (in
graphite on verso of old
mount)
Mrs. Noah L. Butkin

Catalogue no. 23
Edward Steichen
United States, 1879–1973
*Portrait of Rodin with The
Thinker and The Monument to
Victor Hugo*
1902
Toned silver paint
13$\frac{1}{4}$ × 16$\frac{5}{8}$ in.
(33.7 × 42.2 cm)
Iris and B. Gerald Cantor
Foundation

Suggested Reading

Barrère, Jean-Bertrand, *Victor Hugo: L'Homme et l'oeuvre* (Paris: Hatier, 1967)

Barrès, Maurice, *Mes cahiers 1896–1923* (Paris: Librairies Plon, 1994)

Barrès, Maurice, *Romans et voyages* (Paris: Robert Laffont, 1994)

Ben-Amos, Avner, "Les Funérailles de Victor Hugo," in *Les Lieux de mémoire* (Paris: Gallimard, 1984), pp. 473-522

Brombert, Victor, *Victor Hugo and the Visionary Novel* (Cambridge, MA., and London: Harvard University Press, 1984)

Butler, Ruth, *Rodin: The Shape of Genius* (New Haven: Yale University Press, 1993)

Chennevières, Philippe de, *Les Décorations du Panthéon* (Paris: Aux bureaux de *L'Artiste*, 1885)

Chevallier, Pierre, and Daniel Rabreau, *Le Panthéon* (Paris: Caisse nationale des monuments historiques et des sites, 1977)

Cladel, Judith, *Rodin: Sa Vie glorieuse, se vie inconnue*, definitive edn. (Paris: Bernard Grasset, 1950)

Dujardin-Beaumetz, Henri-Charles-Étienne, *Entretiens avec Rodin* (Paris: n.p., 1913)

Fusco, Peter, and H.W. Janson, eds., *The Romantics to Rodin: French Nineteenth-Century Sculpture from North*

American Collections, exh. cat. (Los Angeles: Los Angeles County Museum of Art, in association with George Braziller, 1980)

Galerie Georges Petit, *Claude Monet. A. Rodin* (Paris: E. Ménard, 1889)

Gaudon, Jean, *Le Temps de la contemplation* (Paris: Flammarion, 1969)

Geffroy, Gustav, *Exposition Rodin*, exh. cat. (Paris: Société d'Édition artistique, 1900)

Georgel, Pierre, ed., *La Gloire de Victor Hugo*, exh. cat. (Paris, Galeries nationales du Grand Palais, 1985)

Goncourt, Edmond and Jules, *Journal. Mémoires de la vie littéraire*, 4 vols. (Paris: Fasquelle and Flammarion, 1956)

Greppe, Georges, *Catalogue du musée Rodin* (Paris: Musée Rodin, 1927, 4th edn. 1944)

House, John, ed., *Impressions of France*, exh. cat. (Boston: Museum of Fine Arts; and London: Hayward Gallery, 1995)

Hugo, Victor, *Choses vues*, ed. Hubert Juin, 4 vols. (Paris: Gallimard, 1972)

Hugo, Victor, *Oeuvres complètes. Édition chronologique*, ed. Jean Massin, 18 vols. (Paris: Club français du livre, 1967-71)

Hugo, Victor, *Oeuvres poétiques*, ed. Pierre Albouy, 3 vols. (Paris: Gallimard, Pléiade, 1964-74)

Hugo, Victor, *Pierres*, ed. Henri Guillemin (Geneva: Éditions du milieu du monde, 1951)

Lampert, Catherine, *Rodin: Sculpture and Drawings*, exh. cat. (London: Arts Council of Great Britain, 1986)

Larroumet, Gustave, *L'Art et l'État en France* (Paris: Hachette, 1895)

Larroumet, Gustave, *La Maison de Victor Hugo: Impressions de Guernesey* (Paris: H. Champion, 1895)

Lawton, Frederick, *The Life and Work of Auguste Rodin* (London: T. Fisher Unwin, 1906)

Mayeur, Jean-Marie, *Les Débuts de la Troisième République 1871–1878* (Paris: Éditions du Seuil, 1973)

Nash, Suzanne, *Les Contemplations of Victor Hugo: An Allegory of the Creative Process* (Princeton: Princeton University Press, 1976)

Niven, Penelope, *Steichen: A Biography* (New York: Clarkson Potter, 1997)

Richard, Jean-Pierre, *Études sur le romantisme* (Paris: Éditions du Seuil, 1970)

Rilke, Rainer Maria, *Auguste Rodin* (New York: Sunwise Turn, 1919)

Robb, Graham, *Victor Hugo: A Biography* (London, Macmillan; and New York: W.W. Norton, 1998)

Rodari, Florian, Pierre Georgel, Luc Sante, and Marie-Laure Prévost, *Shadows*

of a Hand: The Drawings of Victor Hugo, exh. cat. (London: Merrell Holberton, in association with The Drawing Center, New York, 1998)

Roos, Jane Mayo, *Early Impressionism and the French State (1866-1874)* (New York: Cambridge University Press, 1996)

La Sculpture française au XIX siècle, exh. cat. (Paris: Réunion des musées nationaux, 1986)

Seebacher, Jacques, *Victor Hugo ou le calcul des profondeurs* (Paris: Presses Universitaires de France, 1993)

Steichen, Edward, *A Life in Photography* (London: W.H. Allen, 1963)

Index

Alexandre, Arsène 77, 81

Balzac, Honoré de 36
Bareau, Georges 16
Barrès, Maurice 24–25, 37
Barrias, Ernest 16, 20
Bartholdi, Frédéric-Auguste 28
Baudelaire, Charles 30
Bazire, Edmond 112
Berment, Roger 76
Bigot, Charles 65
Bonaparte, Louis-Napoléon *see* Napoleon III
Bonnat, Léon 63, 66
Bracquemond, Felix 28
Burty, Philippe 113 n. 27

Carpeaux, Jean-Baptiste 77, 115 n. 44
Chaplain, Jules-Clément 66
Chapu, Henri 66–67, 76, 80, 104, 115 n. 43, 116 n. 73
Chateaubriand, François-Auguste-René de, Viscount 42
Chennevières, Philippe, Marquis de 50, 53, 63, 66, 80, 112 n. 14, 133 n. 27
Chopin, Frédéric 25
Comte, Jules 113 n. 27

Dalou, Jules 66–68, 76, 80, 104, 114 n. 30, 114 n. 31, 115 n. 43, 116 n. 73
David d'Angers, Pierre-Jean 28, 33, 35
Descartes, René 65
Drouet, Juliette 32, 39
Dujardin-Beaumetz, Henri-Charles-Étienne 19, 26, 28, 89

Escholier, Raymond 19

Falguière, Alexandre 67, 104
Foucher, Adèle 31–32

Garnier, Charles 24, 66, 77, 80, 115 n. 43, 115 n. 44
Geffroy, Gustave 77, 105
Goncourt, Edmond de 24, 28, 85, 110 n. 1
Guillaume, Eugène 66–67, 113 n. 27

Harvard, Henry 113 n. 27, 115 n. 43
Hugo, Abel 29
Hugo, Adèle 31
Hugo, Charles 31
Hugo, Eugène 29
Hugo, François-Victor 31
Hugo, Joseph-Léopold-Sigisbert 29
Hugo, Léopold 31
Hugo, Léopoldine 31, 36, 38
Hugo, Victor 15–16, 19, 23–26, 28–31, 35–38, 40, 46–47, 49, 53, 55, 65, 67, 69, 72, 89–90, 99, 110 n. 7, 112 n. 9, 112 n. 19, 115 n. 38

Injalbert, Jean-Antonin 69, 72, 75–76, 80–81, 100, 105, 114 n. 35, 114 n. 37, 115 n. 40

Kaempfen, Albert 80, 113 n. 27

Lafenestre, George 80, 89, 113 n. 27, 115 n. 43
Larroumet, Gustave 16, 66, 68–69, 72, 75–78, 80, 111 n.1, 113 n. 27, 114 n. 37, 115 n. 54, 115 n. 56
Lavoix, René 76–77
Lockroy, Édouard 55, 63, 65–66, 113 n. 24
Louis XV 23, 62
Louis-Philippe 15, 33

MacMahon, Patrice 47
Mantz, Paul 113 n. 27, 115 n. 43
Mercié, Antonin 16, 67
Meurice, Paul 38
Mirabeau, Honoré-Gabriel Riqueti, comte de 15, 16, 62, 65, 69
Mirbeau, Octave 78
Monet, Claude 69
Musset, Alfred de 31

Napoleon I 26
Napoleon III (Louis-Napoléon Bonaparte) 15, 36–38, 46–47, 69

Picasso, Pablo 20
Pradier, Jean-Jacques ("James") 32, 39

Pradier, Marie-Sophie Claire 32, 39
Puvis de Chavannes, Pierre 63

Richard, Jean-Pierre 29
Riqueti, Honoré-Gabriel *see* Mirabeau, Honoré-Gabriel Riqueti, comte de
Rodin, Auguste: works:
Adam 53
Age of Bronze 50, 53, 80, 112 n. 12
Apotheosis of Victor Hugo 16, 97
Burghers of Calais 46, 85
Gates of Hell 45, 50, 53, 72, 97, 115 n. 35
Genius of Sculpture 72
Iris, Messenger of the Gods 97, 99–100
Kiss, The 46
Man with the Broken Nose 112 n. 11
Meditation 90
Monument to Honoré Balzac 16, 46, 72, 85, 90
Monument to Victor Hugo 15–16, 19–20, 23, 32, 39, 45, 62, 65–110, 113 n. 26, 114 n. 35, 114 n. 37, 115 n. 39, 115 n. 55, 116 n. 69, 116 n. 71
St John the Baptist (bust) 112 n. 12
St. John the Baptist Preaching 50
Thinker, The 19, 45–46
Tragic Muse, The 90
Rousseau, Jean-Jacques 65

Sainte-Beuve, Charles 32
Silvèstre, Armand 86
Soufflot, Jacques-Germain 62
Steichen, Edward 45–46, 105, 110 n. 1, 110 n. 3, 116 n. 68

Trébuchet, Sophie-Françoise 29
Turquet, Edmond 50, 53, 112 n. 14

Voltaire, François-Marie 65

Yriarte, Charles 75, 80, 113 n. 27, 115 n. 43, 117 n. 70